ALFRED HITCHCOCK STORYBOARDS

TONY LEE MORAL

TitanBOOKS

CONTENTS

INTRODUCTION 6

Chapter 1—THE 39 STEPS (1935) 20

Chapter 2—SHADOW OF A DOUBT (1943) 32

Chapter 3—SPELLBOUND (1945) 44

Chapter 4—VERTIGO (1958) 54

Chapter 5—NORTH BY NORTHWEST (1959) 68

Chapter 6—PSYCHO (1960) 86

Chapter 7—THE BIRDS (1963) 98

Chapter 8—MARNIE (1964) 114

Chapter 9—TORN CURTAIN (1966) 126

CONCLUSION: TOPAZ (1969) & FAMILY PLOT (1976) 136

GLOSSARY 140

FILMOGRAPHY & INDEX 141

ACKNOWLEDGMENTS 144

THIS IMAGE Portrait of Alfred Hitchcock by Thomas Wright, 1969. Wright was the storyboard artist for *Topaz* (1969).

Introduction

"There is a rectangle up there—a white rectangle in a theater—and it has to be filled."

— Alfred Hitchcock

No other director is more strongly associated with storyboarding than Sir Alfred Hitchcock. His iconic storyboards for the cropduster attack in *North by Northwest* (1959), the shower murder in *Psycho* (1960), and the crows flocking outside the school house in *The Birds* (1963) have created some of the most memorable moments in movie history and are indelibly etched in our minds.

2023 marks the centenary of Alfred Hitchcock's complete assistant directing debut with the short film *Always Tell Your Wife* (1923). At the same time, he was also working as the assistant director and co-screenwriter on *Woman to Woman* (1923) at the Famous Players-Lasky studios in London and would sketch storyboards himself.

Hitchcock used storyboards and production illustrations and sketches to refine his directorial vision, ensuring that his intention was translated to the screen for his collaborators, long before the shooting actually began. Such was his reliance on storyboards, he often said that he rarely looked through the camera, since it was the photographic equivalent of an image that he had storyboarded earlier. As long-time assistant Peggy Robertson remembered, "Every picture I worked with him on was storyboarded and was one of the first requisites of his work."

What exactly is a storyboard? A storyboard can be defined as an illustrator's rendition of the vision of the content creator or director. Storyboards consist of a series of images, like the panels of a comic strip, that gives you an idea of how to compose different scenes. For today's content creators, storyboards are a blueprint or script for the visual medium. They depict how a scene will play out before committing to digital, whether it's a long-form film or a short, viral video.

When storyboarding for a Hitchcock film, the illustrator or storyboard artist is guided by the script, which has benefited from numerous conferences with the director and the screenwriter. The storyboard artist takes the script and documents individual frames and shots, which determine the lighting, editing, props, camera movement, costume, and any other script element.

"[Hitchcock] knew how to hone his visual style so that the movie that he had created in his mind through careful planning, scripting, storyboarding, conferences, and pre-production meetings looked like the one that is shot," remembered Donald Baer, Hitchcock's assistant director on *Torn Curtain* (1966). "He developed his own film language using unconventional camera

angles, moving camera, and point of view to convey the feelings of his characters. His style of directing was pretty much in tune with the staging of how he saw the picture to be shot, and as a result, most of the scenes were storyboarded, and he pretty much directed the film based on his selection of setups."

Hitchcock's usual way of working with his art department began with meetings early in the production schedule to go over each scene. He would sometimes draw rough thumbnail sketches to elaborate a sequence, but this process was also intended to allow his creative team to draw inspiration from each other's ideas. From these preproduction meetings, a general plan was devised for each scene, some more detailed than others.

Through his meticulous preplanning and storyboarding, Hitchcock had a way to visualize a film before the first frame was filmed: "One of the first steps I take upon completing a final draft of a screenplay is to storyboard. As a director, it is my job to communicate my vision of the screenplay to the director of photography, the production designer and the actors. The most important part of communication is what will be captured in the frame. Anything outside of the frame is superfluous. The one thing that the student has got to do is learn that there is a rectangle up there—a white rectangle in a theater—and it has to be filled."

As Patricia Hitchcock, his daughter, recalled, "He had a finished script, he would take a pad, with three rectangles on it, and he would then even draw every single shot in the picture. He would then go over it with the cameraman, so by the time he got on the set, he knew exactly what that movie would look like up on the screen." These storyboards often described the size of the shot, whether it was a medium or a close-up, and whether the camera pulls back or pans left or right. "That's why Hitch says it's a bore for him to get the picture on the screen, because it has all been done already in his office," said Ernest Lehman, who wrote the original screenplay for *North by Northwest*.

Hitchcock famously said he wasn't interested in photographs of people talking. He was more interested in the visual when storyboarding, and telling the story purely in cinematic terms through a succession of images on the screen, which in turn created ideas and emotion, and only seldom leads to dialogue. Hitchcock often boasted that he never needed to look through the camera viewfinder, as everything was in the preplanning and storyboarding. He was most interested in composition and filling that rectangle.

When Scottie takes Madeleine to Muir Woods in *Vertigo*, Hitchcock creates a truly memorable and haunting sequence through framing. He used different frame sizes when storyboarding so that the audience runs through the gamut of emotions that the characters are feeling; especially the long shots of the giant redwoods dwarfing the actors, making them seem small and insignificant, as well as conveying how life can seem short and inconsequential. Hitchcock likened himself to a conductor. "At times, I have the feeling I'm an orchestra conductor, a trumpet sound corresponding to a close shot and a distant sound suggesting an entire orchestra performing a muted accompaniment."

Hitchcock's orchestration of the storyboarding process determined not only the angle but also the size of the image, and each setup contributed to the scene as a whole. He was conscious that the audience shouldn't be aware of the change in image size but should be caught up in the story, as in the sudden switches to close-up on an actor's face to identify with the character.

The future of filmmaking rests with young content creators all over the world today, and storyboards are a legacy of knowledge for the next generation. Alfred Hitchcock was a master storyteller; he had a strong appreciation of the human condition and felt a social obligation to portray that. As all art is about communication and eliciting feelings, it is through storyboarding that artists and content creators can influence the world and make it more relatable through our shared experiences.

OPPOSITE & NEXT SPREAD Storyboards for *Vertigo* (1958). Scottie Ferguson takes Madeleine to Muir Woods where they wander among the tall redwood trees, always green, ever living.

Sc. 173 EXT. BIG BASIN REDWOODS STATE PARK (DAY)
The empty Jaguar in the foreground. The camera moves to a long view of the grove of redwoods. In the distance we see the figures of Madeleine and Scottie wandering among the towering trees.

THIS SEQUENCE WAS FILMED ON LOCATION AND ON THE STAGE.

Sc. 174 EXT. THE REDWOODS (DAY)
Madeleine and Scottie near the massive trunk of a tree. Stream and bridge beyond.

Sc. 174 Madeleine leaves Scottie and moves quickly out onto the bridge.

Sc. 174 Scottie joins Madeleine. After dialogue they cross back to the path in silence.

"VERTIGO" HENRY BUMSTEAD · ART DIR.

Sc. 174 We watch them move away in the distance and disappear behind a tree.

Sc. 176 EXT. REDWOODS (DAY) Madeleine slowly turns and walks away. Scottie in foreground. She disappears behind one of the distant redwoods.

Sc. 174 There comes into view the cross-section of a redwood tree that is on exhibit, with certain of its rings marked to show what it has lived through, and they approach it.

Sc. 177 Scottie moves over, watching her.

Sc. 178 The camera moves over as though it is Scottie looking. It moves far enough to reveal that Madeleine is no longer there. She seems to have disappeared.

Sc. 174 Scottie asks Madeleine if she would like a drink of water. Scottie gets drink of water and Madeleine approaches tree section.

Sc. 175 Scotties comes up behind Madeleine and stands, as she is seemingly unaware of his presence. Their backs are to the camera.

Sc. 175 Insert of rings on tree

Alfred Hitchcock Storyboards

10

As he comes up to her,
the camera eases back and moves around
until it faces her and Scottie.

Sc. 184 They start walking holding together,
and the two figures become small in the
distance, moving away through the tall trees.

PARAMOUNT PICTURES
CORPORATION
ART DEPARTMENT

FROM AMONG THE DEAD

Sc. 179 Scottie eases forward, the camera panning him, to get a better view of where Madeleine went.

Sc. 182 Camera is now among the trees where Madeleine was last seen. As it travels across them, it finally brings her into view. She's leaning against a tree with her head bent back.

Sc. 180 The camera in Scottie's position, moving around, shows that there is no sign of Madeleine whatsoever.

Sc. 181 The camera dollies Scottie down toward the trees.

FROM AMONG THE DEAD

Sc. 183 Scottie comes to a stop as he sees her.

Sc. 184 Madeleine leaning against the tree. Her eyes are closed and she is breathing heavily. In the background we see Scottie approaching her.

BIOGRAPHY

Alfred Hitchcock was born in 1899 in Leytonstone in the East End of London. After attending a Jesuit school, he graduated from the London County Council School of Marine Engineering and Navigation and then began taking night classes in life drawing at the University of London. He started working for the Henley Telegraph and Cable Company in 1914 in the sales department, before being transferred to the advertising department.

In 1920, Hitchcock was hired by the American company The Famous Players-Lasky Corporation, based in London, designing title and dialogue cards for silent films. Working in the art department, as a writer and designer of movie titles, gave him invaluable experience in the power of design to attract an audience. Hitchcock devoted himself to learning his craft, and in 1922 he became a set designer for the newly formed Gainsborough Pictures, having worked his way around the studio's many departments.

He had the instinct for directing right away. 'As a young man and as an art director, I was quite dogmatic... I would build a set and say to the director, 'Here's where it's shot from,'" Hitchcock remembered. For the next three years from 1922 to 1925, he worked as an art director on films such as *Woman to Woman* (1923) and *The Blackguard* (1925), assisting the British film director Graham Cutts. "I was very content then when I was going to get a job as an assistant director," recalled Hitchcock. "Then they said, 'Do you know a good writer?' and I said, 'I'll write it,' and then my friend would be the art director on the picture. [Then] he said he couldn't come, he had another job.

ABOVE Storyboards for *Notorious* (1946). Alicia Huberman visits Sebastian and his mother at their home in Rio de Janeiro where she infiltrates a Nazi organization at a dinner party. In a key sequence Alicia becomes aware of the importance of a bottle of wine being served to the guests, which Hitchcock called the MacGuffin. Graphite pencil on paper 8.5" x 10.25".

THIS IMAGE Alfred Hitchcock's hand-drawn storyboards for *Saboteur*. The drawing shows two views of a man climbing up the arm of the Statue of Liberty. The first view is from above and the second is from the side. Graphite pencil on paper 9.5" x 8"

'So what are we going to do for an art director?' I said, 'I'll do the art direction.'" All this while still serving his apprenticeship!

1925 was an influential year for Hitchcock as he traveled to Berlin to work at the UFA studios on an Anglo-German coproduction. UFA was one of the biggest production studios outside Hollywood and the home of German Expressionist cinema. It had a huge impact on the young Hitchcock, especially the utilization of high- and low-angle shots, and the contrast between light and shade, which Hitchcock incorporated into his own visual style and became instrumental to his films such as *The 39 Steps* (1935), *Shadow of a Doubt* (1943) and *Vertigo* (1958).

Returning to England, he directed his first feature film in 1925, *The Pleasure Garden* for Gainsborough Pictures, followed by *The Mountain Eagle* (1926). From then on, the young Alfred Hitchcock was unstoppable as a director. As he began in silent films, he had a tendency to rely on the camera to tell his story visually. He believed that dialogue should be part of the atmosphere and not the focal point. He would pass his knowledge to his writers, so that they too knew how to tell a story visually rather than relying on words. This script was then translated to the storyboard artist who would often tell the important sequences pictorially.

The storyboards drawn up would then be shared with the cameraman, production designer, and wardrobe. Hitchcock was so meticulous that he considered this phase of the production, the drawing and planning, to be the essential part of making the film, with the filming itself being a 'necessary evil'. The storyboarding is where the creative work and heart of the engine took place.

"I have a strongly visual mind. I visualise a picture right down to the final cuts," Hitchcock wrote in *Encyclopaedia Britannica*. "I write all this out in the greatest detail in the script, and then I don't look at the script while I'm shooting. I know it off by heart, just as an orchestra conductor needs not look at the score... When you finish the script, the film is perfect. But in shooting it you lose perhaps forty percent of your original conception."

During Hitchcock's career, which spanned the classic and golden eras of Hollywood, storyboards were drawn for the cameraman, who would follow them for camera placement. That suited the way Hitchcock worked; he liked to plan ahead. Storyboards then dictated more than they do today, as they are now mostly used for special effects and special sequences.

Shortly after Hitchcock moved to America to work in Hollywood, he was working side by side at the same drawing table with his production designer Robert Boyle on *Saboteur* (1942) when they heard that Pearl Harbor had been attacked. Such was their dedication to designing the movie, they just looked up, and said "Oh, okay", and went back to work! No response aside from that they had to carry on and make this film.

Hitchcock himself hand-sketched the famous Statue of Liberty sequence in *Saboteur,* where actor Norman Lloyd, playing the villain Frank Fry, is hanging off the statue and is being held by the sleeve by the hero Barry Kane, played by Robert Cummings. Norman Lloyd remembers Hitchcock showing him the storyboards for that scene; "I had just come from the New York theater and I didn't know anything about filmmaking. Hitch asked me, 'Would you like to see the Statue of Liberty scene?' And I said, 'But we haven't shot it yet!' So Hitch laid it out in a scroll-like affair, all the storyboards he had done. It was like a Biblical scroll."

Boyle remembers that the newly transplanted Hitchcock became fascinated with America. "He wanted to end the picture on the Statue of Liberty, which he did, just as he wanted to end *North by Northwest* on the four heads, which he did. He became very interested in America and he became a very staunch supporter of America and American ideals."

As Hitchcock started his profession as an art director, the sketches for *Saboteur* show his propensity for storyboards and filling in that rectangle. But the finer, more elaborate work was done by other specialists. Hitchcock worked with some of the best production designers in the business, including Boyle on *Saboteur, North by Northwest, The Birds,* and *Marnie* (1964); and Henry Bumstead on *Rear Window* (1954), *The Trouble with Harry* (1955), *The Man Who Knew Too Much* (1956), *Vertigo,* and *Family Plot* (1976). These production designers created the extraordinary sets for some of Hitchcock's most iconic set pieces, including the top of the Statue of Liberty, the Albert Hall, Mount Rushmore, and location filming in England, the South of France and Morocco. He also worked with graphic designer Saul Bass, who designed the titles for *Vertigo* and *North by Northwest* as well as being the pictorial consultant on *Psycho*.

The studios where Hitchcock made his films employed professional storyboard artists and he worked with some of the best. Illustrators Dorothea Holt, Mentor Huebner, Al Lowenthal, Harold Michelson, Thomas J. Wright and Joseph Musso were all trained in their craft, and superb artists who could paint and draw. Through their sketches, they indicated camera setups, design angles, costume, and production ideas.

When designing for storyboards, an illustrator covers three aspects of the shot: a key sketch to convey tone, atmosphere, mood, lighting, and time of day; a form sketch that shows the size of the image; and an angle sketch that relays the camera position. It's not what the camera sees, it's what the audience sees on the screen that counts, the succession of images moving through the frame.

What's the difference between an art director and a production designer? In a 1963 interview, Hitchcock explained: "Well, art director is not a correct term. You see, an art director as we know it in the studios is a man who designs a set. The art director seems to leave the set before it's dressed and a new man comes on the set called the set dresser. Now, there is another function which goes a little further beyond the art director and is almost in a different realm. That is the production designer. Now a production designer is a man usually who designs angles and sometimes production ideas… The art director is set designing. Production design is definitely taking a sequence and laying it out in sketches."

In the same interview, Hitchcock mentions the famous production designer William Cameron Menzies, whom he worked with on *Foreign Correspondent* (1940), and who is best known for his work on *Gone with the Wind* (1939). Menzies would take a sequence and by a series of sketches indicate camera setups.

Despite Hitchcock's fondness for storyboards, only rarely would an entire film be storyboarded, such as *The Birds,* which required various technical departments to come together to create the complicated special effects required. Storyboards were often created for complicated special effect sequences that required a lot of edits and were dependent on montage. These included the chase up the bell tower in *Vertigo,* the shower scene in *Psycho,* the horse accident in *Marnie,* and the runaway car in *Family Plot*.

For Hitchcock's last film, *Family Plot,* assistant director Howard Kazanjian recalls that ninety-six percent of all storyboards were drawn by storyboard artist Thomas Wright and four percent of the storyboards were done by Hitchcock. Wright did ninety-nine percent of the runaway car illustrations from Hitchcock's instructions, and most of the car sequence was second unit filming also directed by Wright. But a number of the shots didn't pass Hitchcock's critical eye so had to be reshot. The storyboards were shown to the director of photography Leonard South on occasions, as

ABOVE LEFT Alfred Hitchcock's hand-drawn *Saboteur* storyboard is divided into frames marked 17, 18 and 19. The first frame shows three figures standing in the torch of the Statue of Liberty. The second frame shows a view from above the statue as Frank Fry falls. The third frame shows Barry Kane trying to reach out for him. The text reads: 17 Beginning of fall / 18 angle to see water / 19 19a Barry Kane moves off to finger.

ABOVE RIGHT Hitchcock's hand-drawn storyboard for *Saboteur*. Storyboards 20, 21 and 22 show Frank Fry holding onto the arm of the Statue of Liberty. The second frame depicts Barry Kane as he starts down to help Fry. The third frame shows Kane starting down the arm of the statue with a close-up indicating a second shot as Kane gets further down the arm. As Norman Lloyd recalled, "When I fall from the Statue of Liberty, that scene had to be worked without a cut. Hitch said we have to stay with me all the way to the bottom of the statue. That is storytelling, that is camera logic. This is what Hitch had to perfection." Graphite pencil on paper mounted on board

well as the production designer Henry Bumstead or whomever needed them. But generally speaking, the crew did not see them or receive a copy according to Kazanjian.

In 1975, twenty-four-year-old assistant trainee Don Zepfel was involved in the preparation for *Family Plot*, working with Kazanjian, and second assistant director Wayne Farlow. Zepfel's job was to go and get the actors when they were ready for a take. "[Hitchcock] was a very prepared director and an example of how to make a movie," recalls Zepfel. "He had all the storyboards ready, there was really no need for discussion. He had it all planned out in advance. He was involved all the time, sat in his chair next to the camera, never looked through the lens for what I saw. He'd ask what lens was up and always knew what the image would be and didn't bother looking through the camera much. We didn't do a massive number of takes."

For Hitchcock, storyboarding meant that he only shot what was needed, which is why he routinely filmed from 9am to 5pm, a fact much appreciated by the cast and crew, who respected his economy and preparations.

ABOVE Ben and Jo McKenna's hotel suite in Marrakech where a strange man asks for Monsieur Montgomery. The production designer on *The Man Who Knew Too Much* (1956) was Henry Bumstead.

LAYOUT

Through the next few chapters we examine the storyboarding techniques of some of Hitchcock's most famous and popular films, from *The 39 Steps* to *Torn Curtain*, his fiftieth feature, and how they encompass Hitchcock's early British period and influences to his golden years in Hollywood under the studio system.

The 39 Steps has all the ingredients of classic Hitchcock and has been rightly lauded as one of the best films from his British period before moving to Hollywood. The screenplay is storyboarded and celebrated for its sudden switches of location, with an effect like one short story after another. Today's content creators and TikTokers can learn from its rapid switches of scene that lead organically to make a whole film. Hitchcock's experience of German Expressionism is keenly felt in every frame with the help of his Austrian-born art director Oscar Werndorff.

As one of Hitchcock's most celebrated black and white films, lighting plays an integral role in the look of *The 39 Steps*. Hitchcock believed that cameramen, who normally rose up the ranks in the studio starting as assistants, should be sent to the art galleries to study the Dutch masters like Vermeer and gain an understanding of the logic of light. The use of light and shade is again inspired by Hitchcock's time in German cinema.

Hitchcock often cited *Shadow of a Doubt* as his favorite film because of the way plot and character were integrated. In contrast to the dark film noirs of its time, he was keen to avoid cliché, such as the dark alleyway, the cat at night, and the sinister stranger lurking in the shadows. Instead he brought evil out in broad daylight, in the middle of a small American suburban town, in this case Santa Rosa in Northern California. "For once there was time to get the characters into it," said Hitchcock.

The duality of light and shade is reflected in the film's storyboards. Uncle Charlie is often only half lit to show the two sides of his personality. He is often filmed in profile so the audience only sees half his face, such as the famous scene at the family dinner table where he likens the fat greedy women to swine. The theme of the double plays throughout, as demonstrated in the carefully storyboarded opening sequence that draws a psychic connection and parallel between Uncle Charlie and his niece Charlie.

Even though many of Hitchcock's films were fantastical, he was very concerned with achieving realism, which is why his films have often been compared to waking dreams or nightmares. In *Spellbound* (1945), Hitchcock was keen to show the vividness of dreams and hired celebrated Surrealist Salvador Dalí to design the famous dream sequence, as his paintings were uncanny but often rooted in the ordinary and the everyday. As Hitchcock said, "When you have a nightmare, it's awfully vivid if you're dreaming that you're being led to the electric chair. Then you're as happy as can be when you wake up because you're relieved. It was so vivid. And that's really the basis of this attempt at realistic photography, to make it look as real as possible, because the effects themselves are actually quite bizarre."

Storyboards not only determine exactly what the shot will look like, they can even decide what kind of lens should be used. When preparing for *Vertigo*, Hitchcock invented a new lens technique to create the distorting effect required for the character's viewpoint, which is shown in the storyboards, along with a forced perspective. The storyboards also describe the size of the shot, whether it's a medium or a tight close-up, whether the camera pulls back and pans to the right or left, or whether it tilts slightly down or pans up. More sophisticated storyboards have arrows within that indicate where a character or the camera is moving. In *North by Northwest*, arrows on the edges show the camera movement in the Mount Rushmore sequence.

Hitchcock's preferred lens was a 50mm because he said that was the lens of the human eye. Many of his storyboard artists would sketch for a 50mm lens, often called a "normal" lens, because objects remain in perspective approximately as they do with the human eye. As Hitchcock was so keen on subjective viewpoint and a character's point of view, he was very fond of using a 50mm lens, which is frequently used to give a character's point of view. The camera is the audience all the time, and they are seeing it with their own eyes.

Hitchcock spent half of his time avoiding the cliché when writing scenes and storyboards, so

that his films were fresh and inventive. While writing the film, which took a year, Ernest Lehman would come up with an idea, and Hitchcock would often say, "Oh, that's the way they do it in the movies." *North by Northwest*'s storyboards are a great example of using locations to their fullest to enhance and propel the plot, with not only the cropduster sequence but also Roger Thornhill's crazy bidding inside the auction house.

Hitchcock was adamant that he would never film a shot without it having a clear dramatic purpose, one which moves the story and enhances the narrative. He disliked shooting master scenes like television, but shot only what was necessary. This is where storyboarding can help plan content. As Jeff Gourson, an assistant to the editor on *Topaz* (1969), remembers; "[Hitchcock] would shoot a master, but today they shoot a master from beginning to end. What I learnt from him is that you shoot the beginning of the master, which is where your characters would come into the room, and they'll sit down. Then he would stop the camera and then jump down to the end of the scene and pick up the scene where they'd all get up and leave. Because he knew everything in between would be in the coverage that he'd shot. If a scene was three minutes long, he didn't waste three minutes of film shooting stuff that he knew he wasn't going to use. He was so prepared, he knew exactly what he wanted, he had a storyboard, where he wanted to be, and that's how I learned filmmaking."

Storyboards are instrumental to an editor when cutting together montage—the assembly of pieces of film to create a sequence. Montage is the process of editing where one shot, a strip of film or video, is joined with another. Hitchcock often referred to the use of montage and the effect of what he called "pure cinema" to create an emotional response in the audience, namely "the complementary pieces of film put together, like notes of music make a melody." The most famous example of this is Marion Crane's shower murder in *Psycho*, which is made of seventy-eight shots and fifty-two cuts, as well as the later killing of Detective Arbogast in the Bates house.

Hitchcock also storyboarded sequences to build suspense by cutting between shots and scenes, and switching between multiple points of view to shift perspective, cutting between one image size and another to increase shock. In *The Birds*, the crosscutting between Melanie smoking a cigarette and the crows silently gathering on the jungle gym behind her is a superb example of storyboarding for suspense, giving more information to the audience than the characters know.

Storyboards are also crucial in choreographing content that has many special effects, and *The Birds* is an exemplar of this type of filmmaking. Many different studios and departments worked together, sharing the latest technology and resources needed to achieve what was required for such a complex film. Because of the enormous technical problems and challenges involved in the film, the use of continuity sketches was more important than ever.

Hitchcock's use of camera logic, and his innate knowledge of how to frame to maximise impact, extended to his subjective viewpoint. He wanted to put the audience in the character to show how they felt and convey their emotional state. As Boyle said, "Hitchcock was most interested in feelings and was the most subjective director I know." Many of these camera techniques are now industry standard, but Hitchcock used them better than just about anyone else. Storyboarding for the subjective camera reaches its pinnacle in *Marnie*, which is a virtuoso of character identification, point of view and looks exchanged.

While Hitchcock preferred studio filming so he could control both the actors and lighting, the storyboards for the fox hunt in *Marnie* carefully integrate the studio with location filming to convey Marnie's subjective state and fear of the color red. Hitchcock films Marnie in close-ups, so that the audience identifies with her character. The camera then precedes her in movement while keeping her size constant within the image. Then when she discovers something troubling, such as the color red on the jockey's polka-dot shirt or the huntsman's scarlet jacket, the camera will delay for a few seconds more on her face in order to heighten our curiosity, such as when she sees the fox being torn apart by the hounds.

In *Torn Curtain*, storyboarding was essential for the production design and color scheme, especially as the film was mainly set in East Berlin but filmed at Universal. Albert Whitlock's matte paintings for the film are an example of a lost art that has been superceded by digital computer technology. Whitlock painted on a sheet of glass placed in front of the camera. Where the matte is unpainted, the live action occured, and instead of CGI pixels he

ABOVE Uncle Charlie is interrupted by the landlady of a rooming house in *Shadow of a Doubt*. Illustrator Harland Fraser shows the light and shade that permeates the film and the battle between the forces of good and evil.

would create realistic images with his brush and palette on glass.

Today's storyboarding is often called "previsualization" or "previz," a collaborative process that generates premilinary versions of shots or sequences before a film's or content creator's production. Previz is famously used by directors George Lucas, Steven Spielberg and Ridley Scott. It allows filmmakers and content creators to explore creative ideas, plan technical solutions, and communicate a shared vision for efficient production. Hitchcock would have relished today's technology, but he, along with matte artist Albert Whitlock and his talented production designers and storyboard illustrators, are the pioneers who we will explore in this book.

CAST AND CREW

Robert Donat
Richard Hannay

Madeleine Carroll
Pamela

Lucie Mannheim
Annabella Smith

Godfrey Tearle
Professor Jordan

Peggy Ashcroft
Crofter's wife

Josephine Hutchinson
Mrs. Townsend

John Laurie
Crofter

Helen Haye
Mrs. Louisa Jordan

Frank Cellier
Sheriff Watson

Wylie Watson
Mr. Memory

Director
Alfred Hitchcock

Screenplay
Charles Bennett, Ian Hay

Story
John Buchan

Cinematography
Bernard Knowles

Film Editing
Derek N. Twist

Art Direction
Oscar Werndorff

Set Decoration
George Milo (uncredited)

Assistant Director
Pen Tennyson (uncredited)

Art Department
Albert Whitlock (Scenic Artist; uncredited)

Chapter 1

THE 39 STEPS

"I've always believed that you can tell as much visually as you can with words. That's what I learned from the Germans."

— Alfred Hitchcock

PLOT SUMMARY

Richard Hannay, a Canadian visiting London, attends a music hall where Mr. Memory is entertaining the crowd. There he meets Annabella, who takes refuge in his flat where she reveals herself to be a spy. During the night she bursts into Hannay's room with a knife in her back, clutching a map with a house circled in the Scottish Highlands. Hannay sees the assassins outside his flat and goes on the run when he's implicated as Annabella's murderer in a nationwide manhunt. He boards the Flying Scotsman where he meets Pamela, and to escape the pursuing police, he kisses her. But Pamela informs the police, and Hannay jumps off when the train stops on the Forth Bridge. He reaches the house of Professor Jordan and relays what Annabella told him, not realizing Jordan is the mastermind of the spy ring. When Jordan reveals he is missing the top of his little finger on his left hand, he attempts to shoot Hannay, who flees. Hannay goes to the police station, but the sheriff doesn't believe his story, so he escapes and takes refuge in an oratorium where he is mistaken for a political speaker and invited onto the podium. Pamela is in the audience and recognizes him and gives him away to the police. Hannay and Pamela are both taken away in the police car, but Hannay realizes they are agents of the conspiracy, and the pair are handcuffed together. They escape on the Scottish moors and stay the night at an inn. When the men come to the inn looking for them, Pamela overhears and realizes that Hannay is telling the truth, and that the men plan to pick something up at the London Palladium. When they return to London, Hannay recognizes Mr. Memory and realizes that the secrets are not in any files but are actually stored in Memory's head—namely the plans for a silent aircraft engine. When the police try to take Hannay into custody, he shouts to Memory, "What are the thirty-nine steps?" When Mr. Memory instinctively answers that they are a group of spies collecting information for a foreign power, he is shot by Jordan, who is then taken into custody. Hannay and Pamela join hands in unison as Mr. Memory recites the details of the secret engine just before he dies.

The 39 Steps holds a special place in Hitchcock's British films, and has been rightly lauded as a crowd-pleasing favorite. It premiered in the summer of 1935 and was immediately celebrated in both Britain and America. "[Hitchcock] uses his camera the way a painter uses his brush," said the enthusiastic critic for *The New York Times*. It was not only the Hitchcock touch that created this classic, but also the European influence of the art director who created impressionistic sets within the studio.

The film is based on a short novel by John Buchan, whom Hitchcock admired. But when reading the story, Hitchcock didn't see an entire film; he saw promise. Taking some of the novel's characters, plot and locations, Hitchcock set the template for the story of the innocent man on the run, wrongfully accused of a crime he didn't commit, pursued by both the criminals and the police, and caught up in a web of international intrigue.

Hitchcock often named *The 39 Steps* as one of his favorite films because of the rapid and sudden switches of location. The man on the run, in this case Richard Hannay, facilitates the sudden location changes through his actions as he escapes the police who are chasing him for Annabella the spy's death. Once he boards the Flying Scotsman train for Scotland, the film never stops moving. Hannay escapes a police station by leaping out of the window, and immediately loses himself in a marching Salvation Army band. He then enters a public hall, where he's invited up to the oratory platform when he's mistaken for a guest speaker. Then he is handcuffed by the spies and manages to escape with Pamela in tow. The pair take refuge in a rooming inn before heading back to London for the final showdown at the London Palladium where he confronts Mr. Memory who he had met at the beginning.

The film is composed of a series of short stories linked together, which is of interest to today's content creators because of the way the stories are designed. Hitchcock saw each scene as a "little film

ABOVE Professor Jordan arriving at the London Palladium to retrieve Mr. Memory, who has memorised the secret formula for a silent aircraft engine that is to be smuggled out of the country. Courtesy of the BFI National Archive

THIS IMAGE Production sketches for the opening of *The 39 Steps*, set in a music hall where Robert Hannay first meets Mr. Memory and later Annabella the secret agent. It's a great example of a location setting and character bookending the film, as Mr. Memory appears in the London Palladium at the end where he is forced by Hannay to reveal the true meaning of the thirty-nine steps. Only the last sketch of the ticket office is actually used in the production design of the final film after the opening credits. Courtesy of the BFI National Archive

unto itself." When storyboarding for short-form content, whether it is TikTok or Instagram, *The 39 Steps* provides magnificent inspiration to see how Hitchcock interconnected the stories together to make a whole "film of episodes."

Hitchcock worked with his screenwriters Charles Bennett and Ian Hay, and later storyboarded the rapid sequence of events with his art director and illustrators. As Hitchcock said, "Everything is decided on paper… I think a film should be made on paper ahead of time." This stage management is mise-en-scène, namely all the visual elements including what is seen on the set and how the camera films the set and everything within the frame.

Storyboarding these short scenes or stories in *The 39 Steps* delighted Hitchcock because he loved preproduction and spinning a good yarn. "Tell me the story so far," he would often say at the beginning of each day working with his screenwriters. Very often he would take everyday situations, rooted in ordinary events and places, but give them a fantastical spin. As Hitchcock said, "I don't want to film a 'slice of life' because people can get that at home, in the street, or even in front of the movie theater. They don't have to pay money to see a slice of life. And I avoid out-and-out fantasy because people should be able to identify with the characters. Making a film means, first of all, to tell a story. That story can be an improbable one, but it should never be banal. It must be dramatic and human. What is drama, after all, but life with the dull bits cut out?"

Hitchcock's time at the UFA studios in Berlin and his influence from German Expressionism is marked in every set design for *The 39 Steps*. While watching German film director F.W. Murnau at work on *The Last Laugh* (1924), Hitchcock was impressed with the maxim "What you see on the set does not matter. All that matters is what you see on the screen." This is where storyboarding was so crucial to Hitchcock, especially in its use of camera placement. "One doesn't set the camera at a certain angle just because the cameraman happens to be enthusiastic about that spot. The only thing that matters is whether the installation of the camera at any given point is going to give the scene its maximum impact."

The storyboarding of *The 39 Steps* encompasses a myriad of locations, from London music halls,

TOP Richard Hannay on the run from the police on the Scottish moors. The production design is by Austrian Oscar Werndorff, who was highly influenced by German Expressionism. Courtesy of the BFI National Archive

ABOVE Forked roads on the Scottish moors to Inverary. The sets were built on a sound stage at Gaumont's Lime Grove Studios in Shepherds Bush, West London, complete with a stream and running water. Courtesy of the BFI National Archive

TOP The Scottish inn showing the geography of the reception and upstairs where Hannay and Pamela stay the night as a married couple. Later Pamela will eavesdrop at the top of the staircase, which convinces her of Hannay's innocence. Courtesy of the BFI National Archive

ABOVE The bedroom of the Scottish inn. It was deemed risqué for an unmarried couple to spend the night together. The fireplace is where Hannay hangs up Pamela's stockings to dry. The concept is very similar to the final film. Courtesy of the BFI National Archive

TOP Production illustration for the exterior of the crofter's house where Hannay meets the crofter and his wife in one of the film's most memorable scenes. Courtesy of the BFI National Archive

ABOVE Interior of the crofter's cottage with the overhead source light above the kitchen table where Hannay, the crofter, and the crofter's wife share a meal. Courtesy of the BFI National Archive

TOP The sheriff's office where Hannay jumps through the window to escape the police. Hitchcock said, "I made sure the content of every scene was very solid, so that each one would be a little film in itself." Courtesy of the BFI National Archive

ABOVE Production sketch for the Assembly Hall where Hannay is mistaken for a politician and invited to take the podium to speak. Nationalism and identity are some of the themes throughout the film. Courtesy of the BFI National Archive

to Scottish moors with running streams, to the crofter's house, to the mansion of Professor Jordan, the man with the missing finger. The mis-en-scène employed is dark and broody, with long shadows and subdued lighting. Hitchcock's technique enriches the action with his roaming camera, which becomes a character in itself as it follows Hannay in his breathless pursuit.

The film also has a memorable performance from Robert Donat. Hitchcock once remarked that Donat was his favorite leading man, even more so than Cary Grant or James Stewart, because he set the style and prototype for the wrongfully accused man, a central figure in Hitchcock's films. "I could not have wished for a better Hannay than Robert Donat," said Hitchcock. "One of the chief reasons for his success—in addition, of course, to his natural looks, charm, and personality—is the good theatrical training he has behind him."

Hitchcock's confidence in Donat was justified; Donat went on to win the Best Actor Oscar® in the 1940 Academy Awards® for his performance in *Goodbye Mr. Chips* (1939), beating strong competition from Clark Gable for *Gone with the Wind*, Laurence Olivier for *Wuthering Heights* (1939), Mickey Rooney for *Babes in Arms* (1939), and James Stewart for *Mr. Smith Goes to Washington* (1939).

The 39 Steps did very well at the box office in both the UK and the US and secured Hitchcock's reputation as a highly talented director with his own unique visual style. So successful was Hitchcock in coordinating a succession of memorable scenes and images, with rhythmic movement and effects, that *The 39 Steps* was Hitchcock's calling card to Hollywood. But he was also aided by a great production designer from Austria and Germany and his roots in German Expressionism.

ABOVE Production sketch for Robert Hannay's rented London flat, where he is persuaded by Annabella the spy to take her home—rather daring for 1930s Britain, when they had just met. Notice the dark interiors and long shadows contrasting with light from the windows. The furniture is draped with sheets, hinting that Hannay has recently moved in. Graphite pencil and gouache on watercolor paper. Courtesy of the BFI National Archive

OSCAR WERNDORFF

As Hitchcock had been influenced by German Expressionism, he turned to an Austrian art director named Oscar Friedrich Werndorff. Born in Vienna in 1887, Werndorff studied architecture as well as working in building design. One of his most significant assignments was working for the last emperor of Austria as chief architect. With an interest in German theater and film, Werndorff became prolific in the 1920s, designing sets that combined his German Expressionist sensibilities with more realistic elements. His more notable films included *Nosferatu* (1922), directed by F.W. Murnau; *Varieté* (1925), working with German film director E.A. Dupont; and *Pandora's Box* (1929), directed by Georg Wilhelm Pabst.

Werndorff moved to Britain from Germany in the late 1920s, as a Jewish political refugee, one of many German emigrés to do so. He then worked for a decade in the British film industry on films such as *The Bells* (1931), which he co-directed with Harcourt Templeman, and Victor Saville's *First a Girl* (1935). Along with a close attention to set building and expressive mise-en-scène to achieve realism, Werndorff believed the key to a successful production was in the harmonious working relation between the director, his cameraman and the art director.

Michael Balcon was the studio head who had signed Hitchcock to a multi-picture deal which included *The 39 Steps*. The Gaumont-British Picture Corporation had its own company, Lime Grove Studios in Shepherd's Bush, used for film productions, with its Gainsborough Studios in Islington located on the south bank of the Regent's Canal. Gaumont had its own art department, up a flight of stairs overlooking the entrance of Stage 1. Art directors like Oscar Werndorff and Alex Vetchinsky worked here, designing production sketches for films. Werndorff was known affectionately as "Uncle Otty" by his colleagues.

Werndorff designed the sets for *The 39 Steps* at Lime Grove. This was Werndorff's second

THIS IMAGE Production sketch for Richard Hannay's rented London apartment. The bright face of the front lit by the street lamp contrasts with the dark shadows where the spies wait. Courtesy of the BFI National Archive

LEFT Production sketch for Oscar Werndorff's set design for a bridge on the Scottish Moors. The impressionistic use of light, shade, and optimal use of space in a studio is used for Richard Hannay on the run. Courtesy of the BFI National Archive

collaboration with Hitchcock after working with him on *Waltzes from Vienna* (1934). Werndorff drew a number of production sketches in black and white charcoal, designing the sets and conveying the mood and tone of the film, including Hannay's flat behind Langham Place where he brings back home Annabella the spy; Hannay's kitchen where he cooks her a meal; Hannay fleeing London on the Flying Scotsman train; Hannay alone on the Scottish moor; the crofter's house where he takes refuge; as well as the music hall which opens the film. His storyboards show shadows, black and white contrast, and interesting and oblique camera angles. Hitchcock, being a talented artist himself, undoubtedly drew some sketches himself for inspiration, especially when it came to set design.

"If you're content to do a small portion of the set very accurately it's much better than trying to do a whole street," said Hitchcock. "This is a principle which I've stuck to ever since I was an art director. I was working the UFA lot in Germany in its heyday and there I picked up a great deal of insight into the techniques of set building and perspective of every kind." It would seem that Hitchcock and his art director Werndorff were very well matched. "Good art direction must give you the atmosphere of the picture without being too noticeable," Werndorff was quoted as saying. "The best 'sets' in my experience are those which you forget as soon as the film is over and the lights go up again in the theater. The first essential in the film is the action of the characters. The art director's job is to provide them with a background—and a background it should remain at all costs."

Werndorff himself was impressed by new design concepts and techniques in British cinema, while introducing his own pioneering camera techniques such as a high expressive mis-en-scène which utilized stairs, mirrors, dark shadows, and the black and gray ominous landscapes of the Scottish Highlands. He also economized sets within the studio space, creating a bridge over the moors complete with running stream.

To match the sets and production design, *The 39 Steps* is a study in Hitchcock's roots in silent cinema and the UFA visual aesthetic. Hitchcock famously said he wasn't interested in photographs of people talking, but had a succession of images he had to play out on screen to tell a story—this is aptly demonstrated in *The 39 Steps*, such as the scene with Hannay, the crofter and his wife, which is wordlessly played out through the interplay of the characters. The crofter's wife discovers from a newspaper that Hannay is on the run from the police, while the crofter is suspicious that Hannay is having an affair with his wife. All of

LEFT *The 39 Steps* was filmed at Lime Grove Studios in London with some shooting on the rail line in Hertfordshire which doubles as the 1.5 mile-long Forth Bridge. This is where Hannay jumps off to hide from the police who are searching for him on the train. Courtesy of the BFI National Archive

this is wonderfully played out in the visuals and looks exchanged over the dinner table.

Also prevalent in the storyboarding is camera placement and Hitchcock's trademark use of high- and low-angle shots. The high shots show the abyss with Hannay by the pillar of the Forth Bridge, which contrast with the low shots that evoke a feeling of menace. In a low-angle shot, the camera looks up at what is being photographed. Generally it's used to show a character looking dominant. "The low camera used is to get an abnormality," Hitchcock said.

Hitchcock's moving camera takes on a life of its own in *The 39 Steps*. "One of the first essentials of the moving camera is that the eye should not be aware of it, but should be on the character moving," said Hitchcock. "Imagine you have a scene between two people in a quarrel, a man and a woman. And you've got them on a sofa in a close shot, cutting just below head and shoulders, the two of them, and the girl gets up angrily and walks across the room. I will follow her in close-up across the room to maintain the mood. But very often this isn't done; a cut back to a long shot is used instead. Because the mood of the woman's emotional disturbance is there, you should never cut back—at least not until she gets over it and calms down. Then you can ease the camera out, ease it back unobtrusively."

To complement the theme of the couple being handcuffed together for most of the film, there's also a fantastic closing image at the end, as their hands join in unison, aptly showing the progression of the journey Hannay and Pamela have made while being tied together.

Oscar Werndorff would go on to work with Hitchcock on the storyboards for *Secret Agent* (1936) and *Sabotage* (1936), but sadly would die only three years later in Wembley in 1938. But another long-standing association began during this time, between Hitchcock and an artist named Albert Whitlock.

Like the director, Whitlock was born in London's East End. With no formal art training, he learned his apprenticeship with pioneering British matte painter Walter Percy Day. He started work at Gaumont Studios in 1929, where he worked as a grip, assisting in the lights and carpentry and as a set builder. Whitlock also trained as a sign painter, and he had already done some work for Hitchcock, assisting in the miniature effects for *The Man Who Knew Too Much* (1934). He would then go on to paint all the signs for *The 39 Steps* and *The Lady Vanishes* (1937). Whitlock would later follow Hitchcock to America in 1954, and the two would be reunited working together on *The Birds*, where he would work as a matte painter and his pictorial design would influence many more Hitchcock films to come.

CAST AND CREW

Joseph Cotten
Uncle Charlie

Teresa Wright
Charlie Newton

Macdonald Carey
Detective Jack Graham

Patricia Collinge
Emma Newton

Henry Travers
Joseph Newton

Wallace Ford
Detective Fred Saunders

Hume Cronyn
Herbie Hawkins

Edna May Wonacott
Ann Newton

Director
Alfred Hitchcock

Screenplay
Thornton Wilder & Sally Benson
& Alma Reville

Story
Gordon McDonell

Cinematography
Joseph A. Valentine

Film Editing
Milton Carruth

Art Director
John B. Goodman

Associate Art Director
Robert Boyle

Assistant Director
William Tummel

Visual Effects
John P. Fulton

Art Department
Dorothea Holt (Illustrator; uncredited),
Harland Fraser (Illustrator; uncredited)

Chapter 2
Shadow of a Doubt

"This film has brought murder into the home where it rightfully belongs."

— Alfred Hitchcock

PLOT SUMMARY

Charles "Uncle Charlie" Oakley is living in a rooming house on the east coast when two men come looking for him. He leaves town to stay with his sister Emma and her family in Santa Rosa, California. His niece Charlotte "Charlie" is infatuated with her uncle, but becomes suspicious about his secretive behavior, especially when two men come to the house posing as interviewers for a national survey. One of the men, Jack Graham, asks Charlie out and explains to her that he's a detective looking for the 'Merry Widow Murderer' and says that Uncle Charlie is one of the chief suspects. When Charlie confronts her uncle, he admits that the men are looking for him but is exonerated when the other suspect is chased by police and killed. Charlie continues to be suspicious of her uncle and has some near-death experiences, by falling down the stairs and being trapped in the garage with exhaust fumes running. Uncle Charlie announces he is leaving town and boards a train with a rich widow, but Charlie follows him and he realizes he must kill his niece. When she tries to get off the moving train, Uncle Charlie attempts to push her to her death, but he himself falls into the path of an oncoming train and is killed.

ABOVE Production illustration, with Ann Newton eating an apple while reading *Ivanhoe*. Remarkably the illustration is very similar to the composition in the final film, with the banister in the foreground, columns inside the house, and similar style of lamps and furnishings.

While working as a graphic artist, Hitchcock was very influenced by how German Expressionism used light and shade to create mood and atmosphere, which was integral to films like *The Cabinet of Dr. Cagliari* (1920), *Nosferatu*, *The Last Laugh*, and *Metropolis* (1927).

Hitchcock believed that cameramen should study the great artists and Dutch masters like Vermeer for an appreciation of light and shadow to create visual depth and contrast. This concept of painting with light was paramount to the development of his storyboards, especially the use of shadow; how a scene or character is lit has a great effect on how the audience responds to them. Lighting plays a key role in enhancing a film's look, creating mood and suspense through the use of shadows and architecture.

Chiaroscuro in particular is a film lighting style that emphasized extremes. Hollywood adapted this lighting in the 1940s with the development of film noir, particularly low-key lighting which created light and shadow, in addition to the standard use of three-point lighting, which is made up of a key light, a fill light and a back light.

Shadow of a Doubt, released in 1943, is an excellent example of 1940s film noir. Hitchcock often cited the film as his favorite, because of the psychologically plausible and nuanced characters, star performances from his leads, and the fact that it was his first truly American film. Set in Santa Rosa, the film follows small-town life and the disruption of a family when Uncle Charlie comes to visit. His niece Charlie slowly becomes suspicious that he is in fact the 'Merry Widow Murderer' responsible for a number of deaths of wealthy women; a serial killer. The subject matter, the internal psychology of the characters, the moral ambiguity, all lend itself well to the Expressionist storyboards and the use of extreme light and shade to show the good and evil of the central characters. The intrusion of menace

into a small town fascinated Hitchcock, as he said: "This film has brought murder into the home where it rightfully belongs."

While effectively using light and shade, especially the way Uncle Charlie is lit to show the dual nature of his personality, Hitchcock was also keen to avoid cliché. In contrast to the dark, urban noir films of its time, evil is found in broad daylight, lurking beneath the surface of a small American town like Santa Rosa. It was one of the most satisfying films for Hitchcock because character and location combined to enhance the plot. "For once there was time to get characters into it," he said, which is one of the reasons why he describes *Shadow of a Doubt* as his favorite of his films.

Thornton Wilder wrote the screenplay in Hollywood, but before a line was written, he and Hitchcock spent some time in Northern California, going to the film's setting of Santa Rosa so that they were familiar with the feel of the whole town and its people.

BELOW The Newton family at dinner, a typical American family in Santa Rosa, with Uncle Charlie at the head of the table, prior to him giving gifts for everyone, such as a mink stole for his sister Emma, and a wristwatch for her husband. Dorothea Holt is credited as the illustrator. It was Holt's good instinct and training to show where the light source is coming from, an overhead lamp creating contrast and shadows. The lighting cameraman would later use this sketch as reference.

DOROTHEA HOLT

In 1939, Hitchcock had been invited over to Hollywood for a seven-year contract, starting with *Rebecca* (1940). The adaptation of Daphne du Maurier's novel set in Cornwall was a natural one for Hitchcock to direct, with his familiarity with England and its Gothic melodrama. The figure behind the storyboards for *Rebecca* was Dorothea Holt. She was one of the few female storyboard artists in the industry, drawing the sketches for some of the most famous films of the time, including *Gone with the Wind*, *Citizen Kane* (1941), and *White Christmas* (1954). Born with an artistic streak in Los Angeles in 1910, she was influenced by a grandmother who used to paint and who was very independent, traveling through Britain during the 1930s depression by herself. Holt was raised to be independent, with the belief that a woman could do anything. As her daughter Lynne acknowledged,

"My mother was raised so that she didn't know what a glass ceiling was, growing up. She wasn't raised to think she couldn't do anything just because she was a woman." Holt was also influenced by a visit from a glamorous teacher to the Westlake School for Girls where she was attending, who taught them how to use a ruling pen and elevation from a floor plan.

She enrolled in the University of Southern California, and graduated in 1935 from the school of architecture, being one of only five women out of a group of 120 in the class. There she also became good friends with Robert Boyle, who also became a production designer and who was at the school at the same time. They were taught on Saturdays by a watercolor artist named Paul Sample, as they listened to the football games outside or on the radio while they worked. Then she went to the Art Center College of Design in Los Angeles and was in

LEFT Portrait of Dorothea Holt, illustrator for *Rebecca*, *Shadow of a Doubt*, *Saboteur*, *Rope* (1948), *Rear Window*, *To Catch a Thief* (1955), and *The Man Who Knew Too Much* (1956). She is also credited as Dorothea Holt Redmond for her later work with Walt Disney. Courtesy of Lee Redmond and Lynne Jackson.

OPPOSITE One of Dorothea Holt's production illustrations for *Rebecca* showing the house Manderley from a distance. Holt's use of black and white watercolors have a wonderful evocative mood and she is famous for her washes. Her technique was to wet the entire sheet of paper with clear fresh water, and soak it top to bottom, ensuring that the entire paper was evenly wet. Then she would mix up a large amount of color, and squeeze it from the brush in big drops over the wet paper, starting at the top, and then rocking the board back and forth, until she achieved the gradated wash she wanted. This method results in the luminescent glow particular to Holt's work.

the first graduating class as an illustrator in 1936. The Art Center had opened in 1930 with Edward A. "Tink" Adams serving as its director.

 Holt was interviewed by Hans Drier at Paramount, who liked her but had reservations about hiring her because she was a woman. So she went to Universal Studios for a short period of time, which was known for its horror and monster pictures. But Tink Adams was furious that his best student's talents were wasted there, so he introduced her to producer David O. Selznick, who was looking for illustrators to sketch the interiors for the Selznick International Pictures epic *Gone with the Wind*. At Selznick's she storyboarded the elaborate sets for Tara, including the grand staircase and foyer, using watercolor, pencil, and India ink. Holt recalled working on the film was a frustrating experience, as, for the first six months while they waited for the script to be approved and production to begin, she endlessly designed variations of the Tara staircase because Selznick kept changing his mind. "I painted that damned staircase at least twenty-five times!" she told production designer Peg McClennan in a series of interviews.

 When Holt was first hired at Selznick's art department, she was the only female illustrator in the workplace; there were jokes about adding a women's restroom. In order to use the ladies' room, she had to walk all the way across the lot, to the administration building, because there was one there for the secretaries. The men were upset she was hired, and built a screen around her draughting table, partly because they felt she needed her own privacy, but also to keep a degree of separation from her. However, Holt had a dry sense of humor, and would throw black stockings over the side of the panels to make her mark. Undoubtedly it was that sense of humor that made her appeal to Hitchcock, who liked the company of strong women. At the studios, she would often work twelve to eighteen hours a day, and often wouldn't see her family in the morning or when returning at night.

REBECCA

Dorothea Holt's talent made her rise quickly in the industry and she was asked by Selznick to work on *Rebecca*, Hitchcock's first American film. Selznick was keen on being faithful to the novel, including the famous opening line, "Last night, I dreamt I went to Manderley again," beginning with the forbidding gates leading to the mysterious exterior of the house.

Manderley itself becomes a character in Hitchcock's film, just as other houses do in his later films, including Minyago Yugilla in *Under Capricorn* (1949), the Frank Lloyd Wright-inspired house in *North by Northwest*, the Bates house in *Psycho*, and the Brenner house in *The Birds*. Hitchcock says of Manderley, "In a sense the picture is the story of the house. The house was one of the three key characters of the picture." He also said that the house had no geographical place, it was separated from the outside. The audience get an impression of the village from the inquest scene, but all the action takes place inside the house, which adds to the sense of claustrophobia.

The script for *Rebecca* called for Holt to design the gates to Manderley, not only for the dreamlike opening, but for the scene where Maxim de Winter (Laurence Olivier) arrives with his young bride, the second Mrs. de Winter (Joan Fontaine). She also sketched them with a British racing green convertible going through the gates of Manderley. After the film was finished the prop department put the car up for sale for $1,500; Dorothea and her husband Harry Redmond were tempted to buy, but with the war coming thought it wasn't practical.

Holt was renowned in the industry for her watercolor washes, such as the ones she designed for Manderley, which were fresh and bright. Her approach was to have no fear when designing them. She would start a rough sketch in pencil, working on a Whatman watercolor board, which is the only one she liked to work with, and she would use a natural sponge to dab water on the board. Then she would add Winsor & Newton paint to that water and it would spread. She was really good at assessing how thick the water should be and she said, "You had to *feel* it." Her secret was to use a sponge to soak up any excess water, picking up the Whatman board and tilting it, to let the painted water run in different areas to create clouds. If she knew she was going to have a lot of clouds, she would use a material called frisket which would bind to the board like an artist's rubber cement.

Then she would paint the whole sky as watercolor wash, and once it got dry enough that it couldn't smear, she would go back, removing the frisket, and building architecture or trees where the frisket was. Afterwards she would use a special kind of eraser to rub that over the frisket, rolling it up to expose the unpainted area of the Whatman board. That way she could have a continuous sky and not worry about having to paint over it.

As Hitchcock was an illustrator and set designer before becoming a director, he had an eye for detail and knew what he wanted, planning his films well before the camera rolled. The set was designed by the art director or the production designer, and blueprints were drawn up by draughtsmen, and then built by the construction team on the stage. While the building was happening, the illustrators were given quarter-inch floor plans of the set and asked to create beautiful set illustrations in color, with lighting and furnishings and even characters in costume.

Holt had worked as an assistant for William Cameron Menzies, the first person in the industry to be awarded the credit of production designer for his work on *Gone with the Wind*. Undeniably talented as an illustrator, he won an honorary Academy Award® for outstanding color production design for the film. Holt admired Menzies tremendously, but felt that he wasn't willing to share the limelight. When an interviewer from the *LA Times* came to do a story on Dorothea as the only woman in the art department and mistakenly called her a production designer instead of an illustrator, Menzies was furious.

Working with Menzies again on *Rebecca*, Holt wasn't given a great deal of direction for drawing storyboards as a series of shots, which she disliked doing, but she enjoyed sketching the production set illustrations and figured out the details herself. This involved designing the exterior of Manderley, Maxim de Winter's bedroom, the upper passage to Rebecca's suite, the morning room, the dining room and the library. She would paint and then show several designs to Menzies, but also would come and talk directly to Hitchcock himself. Her illustrations

would then go to the draughting department and sets would be built from it.

Holt excelled at painting the master shot more than any other and laid them out with camera lenses in mind. She would start sketching in pencil, using watercolor boards to design her production illustrations. She would lay out a draftsman triangle, allowing her to figure out what a certain size room would be like. A draftsman triangle, or a T square, is a device cut in angles, which allowed her to lay out a room to see what it would look like with a certain lens. She had one for a 25, 35, and 50mm lens; mostly she would use the 25mm and 35mm device. Starting with the plan of the room, she would take this device to give her a point of view (POV) point, relative to the floorplan; and once she had that it wasn't that hard to project perspective. She would take a pushpen, and put it on the Whatman board and everything would rotate from that point left or

BELOW Production illustration and set design sketch for *Rebecca*, 1940 drawn by Dorothea Holt. Holt would research in the library the fine period details of antique furniture, wallpaper, and curtains. 8" x 10"

right. She also used a long list of colors, unlike most painters, and kept her palettes covered to preserve the paints, using a large sheet of white milk glass or vitrolite (which is no longer made), as the white kept the colors pure.

Holt loved drawing architecture in particular. At that time, the studios had massive research libraries and incredible props and furniture departments with genuine antiques. Using a combination of books from the library, Holt studied the architecture and interior design. If working on a period picture, then she would go to the library to research, and then she would go to the furnishing rooms and prop rooms, and see what they had from that period.

Very few people were as knowledgeable about architectural styles as Holt. Some of the furnishings that she painted were older than the time period the film was set—never newer but quite often older, as people collected antiques too. She would then paint the props that the studio already owned, usually selecting from their extensive collection of antiques, with very few reproductions. Holt would go down and look in the furniture of the prop department and take note of the details of architecture, such as column styles, door knobs and moldings around the window.

Rebecca was the first film in which Hitchcock experimented with a tracking camera rather than the use of montage, because he wanted to move around the big house of Manderley to imply the ghostly presence of the first Mrs. de Winter. Holt's drawings depict plan views of the front porch and interior stairway, showing camera positions, angles, and movement, and some also depict the movement of the actors, with emphasis on the mobile camera. She included a massive amount of detail in these drawings, conveying a sense of mood and atmosphere.

When Selznick subsequently loaned out Hitchcock to other studios, he would do so at a hefty sum. Similarly, he loaned Holt out to Universal for triple the rate that she was working for him. The loan-out of both Hitchcock and Holt would create one of the director's most beloved films. *Shadow of a Doubt*, though produced by Universal Pictures, actually began with the head of Selznick International Pictures story department, Margaret McDonell, who thought that the story of Uncle Charlie, who was based on a real-life serial killer of middle-aged ladies, would interest the Master of Suspense.

ABOVE Alfred Hitchcock's hand-drawn rough storyboard shows part of the sequence in which Uncle Charlie gives niece Charlie a ring.

SHADOW OF A DOUBT

Reunited with Boyle as the production designer, Holt's job was to interpret Hitchcock's directorial style, including framing, camera movement and angles, and especially lighting. Hitchcock was "one of her favorite people to work with. She just loved his personality and his taste," said Holt's daughter Lynne. "Hitchcock would come to her and tell her what he wanted. She would draw it, and then he would take the sketch from her, and walk out and tell the crew, 'This is what I want, with these shadows and this way.' She was able to click in on what he wanted, namely because I think she liked doing that. That was a challenge."

Although Holt didn't relish laying out storyboards, she enjoyed the design of production illustrations. Working with another illustrator named Harland Fraser, under the supervision of Boyle, the team laid out sketches for Uncle Charlie on his bed in the rooming house, niece Charlie in her room at home in Santa Rosa, many scenes in the Newton's home, including the family around the dinner table, as well as a whole sequence of illustrations to depict niece Charlie's frantic run to the library before it closes as she seeks the incriminating newspaper article which her uncle tried to hide.

One of the production team's tasks was to find an all-American house for the Newton family in Santa Rosa. Boyle and his team found one at 904 McDonald Avenue, built in Italianate Victorian style with a wraparound front porch. It was the oldest house on the tree-lined street in the McDonald Historic District. The house had also been the meeting place for the Saturday Afternoon Club, one of the first women's groups, established in 1894. Hitchcock was looking for a house that was lived-in and worn, a typical American home which the National Surveyors would want to come to visit.

The production illustrations laid out the famous opening of *Shadow of a Doubt*, as the theme of the double is established by Hitchcock's tracking camera; successive shots show the larger view of the city, then the exterior of the house, the window, and then Uncle Charlie and niece Charlie both lying on their respective beds; six shots consistently right for Uncle Charlie and six shots consistently left for niece Charlie. The parallel composition suggests the connection between the two characters, which niece Charlie herself describes as 'telepathy' to the lady at the telegram office. "We're like twins. You said so yourself," says Charlie to her uncle.

What's remarkable from the illustrations are the fine historical details, such as the wallpaper, bed, lamps, and lighting. Holt was a master of light and shade, which showed in her production illustrations and storyboards for *Shadow of a Doubt*, and the gradation of light, medium, and dark. She loved working with shadows, and had previously worked well with Greg Toland, the cinematographer for *Citizen Kane*. With the advent of color in films came the ability to use colors to separate objects, but there was a danger of everything becoming flatly lit, whereas Holt's production illustrations for *Rebecca* and *Shadow of a Doubt* show an awareness of where the lighting source came from.

Holt's lighting sketches together with Hitchcock's background in German Expressionist technique added a sense of menace to the illustrations, with their long shadows, enclosed spaces, darkness and light, adding danger to the quiet American town. Hitchcock was keen to avoid cliché in all of his pictures, and thought that evil was seductive; so often Uncle Charlie is filmed in bright sunlight, especially when he is reunited with the Newton family on the train platform, offset by the clouds of black smoke from the steam engine. "A lucky accident" is the way Hitchcock described the effect to Truffaut. He had asked for the black smoke but with the position of the sun, he didn't realize he would get such a shadow on it. It aptly demonstrates that the devil is in town.

Everyday settings were given a twist with the use of chiaroscuro lighting. There is a motif of doors and windows throughout the film suggesting the menace and secrets which are so often found behind them. Holt's production sketches and storyboards showed all the detail in the finished film. In the famous library sequence, Hitchcock uses a high angle to show the isolating effect when Charlie discovers the truth about her uncle. "If you wanted to show loneliness, you show one person alone in the room. I remember in the film *Rebecca*, the young girl there was brought to a big house, she was very scared. So naturally when she walked into this big room, you made her small deliberately. In fact to make her feel afraid, I even

TOP Production design sketch by Boyle for Uncle Charlie in the Philadelphia rooming house when his landlady Mrs. Martin tells him that two men have been looking for him. The composition is remarkably similar to the filmed sequence.

ABOVE Production illustration for niece Charlie's bedroom. The use of light and shade accentuates the hidden menace found lurking in the home, with charcoal brushes and cotton cloths to create the light and shade effect. The composition is a mirror image of Uncle Charlie's intro so psychically linking the two characters.

ABOVE Charlie leaves her house and rushes to the public library, which closes at 9pm. Staircases play a prominent role in Hitchcock's films. Dorothea Holt is credited as the illustrator for this sketch and the library series is credited to Harland Fraser.

had a fan blow her hair slightly, even though the windows weren't open."

After finishing *Rebecca* and *Shadow of a Doubt*, Dorothea Holt enjoyed a collaboration of seven pictures with Hitchcock, including *Saboteur*, *Rope*, *Rear Window*, *To Catch a Thief*, and *The Man Who Knew Too Much* (1956). Joseph MacMillan 'Mac' Johnson was the art director for *Rear Window*, whom Holt had worked with on *Gone with the Wind*. Whilst Mac designed L.B. Jefferies' apartment, he tasked Holt to design all the neighbors' apartments across the Greenwich courtyard, which she had much fun doing.

After twenty years of working in the motion picture industry, Holt decided to leave to concentrate on raising a family, and she joined the architecture firm of William Pereira and Charles Luckman. There she designed the famous 'spider' for LA International airport, and the Los Angeles County Museum of Art. In 1964, she started to work for Walt Disney as a designer under her married name Dorothea Holt Redmond.

When she died in 2009, the city of Los Angeles dedicated a day in Holt's honor. One of the things she was proud of is not being scared about what to paint but just jumping in and starting, and with a couple of quick strokes of a sable hair brush, she had a sketch or a portrait. As well as being a pioneering woman in a male-dominated industry, Dorothea Holt's legacy will be the quality of her washes, her fine historical detail and her use of light and shade.

Shadow of a Doubt • Chapter 2

CAST AND CREW

Ingrid Bergman
Dr. Constance Petersen

Gregory Peck
Dr. Anthony Edwardes / John Ballantyne

Michael Chekhov
Dr. Alexander Brulov

Leo G. Carroll
Dr. Murchison

Rhonda Fleming
Mary Carmichael

John Emery
Dr. Fleurot

Norman Lloyd
Dr. Garmes

Bill Goodwin
House Detective

Steven Geray
Dr. Graff

Director
Alfred Hitchcock

Producer
David O. Selznick

Screenplay
Ben Hecht

Adaptation
Angus MacPhail

Story suggested by
Francis Beeding

Cinematography
George Barnes

Supervising Film Editor
Hal C. Kern

Art Department
Salvador Dalí (Dream sequence based on designs by)

Art Direction
James Basevi

Assistant Director
Lowell J. Farrell

Chapter 3

SPELLBOUND

"The analyst seeks only to induce
the patient to talk about his hidden problems,
to open the locked doors of his mind."

— Alfred Hitchcock narration, introduction to Act One, *Spellbound*

PLOT SUMMARY

Dr. Constance Petersen is a psychoanalyst at Green Manors psychiatric hospital in Vermont. The director Dr. Murchison is being forced into retirement and is replaced by the younger Dr. Anthony Edwardes, who soon falls in love with Dr. Petersen. She notices that he has phobias such as parallel lines against a white background, suffers from anxiety attacks, and carries a guilt complex. After he disappears one night, the hospital learns that the real Edwardes may have been killed and replaced by an impostor. Petersen follows Edwardes to a hotel in New York where he is staying under the pseudonym John Brown. When Brown's photo appears in the newspaper as wanted, they board a train to go and stay with Dr. Alexander Brulov, Petersen's former professor. Together they analyze Brown's dream of playing cards in a gambling house while his card partner, an older man, is accused of cheating by the masked proprietor. The older man falls off a sloped roof, and the proprietor is found standing behind a chimney with a melted wheel in his hands. The dream concludes with Brown being chased down the hill by a giant pair of wings. Petersen interprets that Brown's fear of dark lines on white are ski tracks in the snow, and that the real Edwardes met his fate in a skiing accident at the Gabriel Valley ski lodge. Petersen and Brown travel there, and while skiing Brown recalls accidentally knocking his brother onto a spiked fence and killing him. His real name is John Ballantyne and he is soon arrested and convicted for the murder of the real Dr. Edwardes. The previous director Dr. Murchison is reinstated, but when he lets slip that he knew Ballantyne, Petersen reinterprets the dreams to conclude that the masked proprietor was Murchison, and it was he who killed Edwardes and framed Ballantyne. At the end, Murchison kills himself with a gun and Petersen and Ballantyne are united in marriage.

Hitchcock had a seven-year contract with David O. Selznick, but after *Rebecca* he was loaned out by the producer to direct films such as *Suspicion* (1941), *Shadow of a Doubt*, and *Lifeboat* (1944) for other studios. During this time, Hitchcock and his wife Alma were developing a novel called *The House of Dr. Edwardes*, for which they had bought the film rights, and which would eventually become *Spellbound*. The story is about an amnesiac played by Gregory Peck who falls for another doctor, Constance Petersen. Through the course of the film, Dr. Petersen helps Edwardes discover his true identify, unravel his childhood trauma, and also expose a murderer. Petersen helps him, with the aid of another doctor, through psychoanalysis and dream theory.

Hitchcock was very interested in dreams himself, as his screenwriter for *Marnie*, Jay Presson Allen, would later testify. He often asked her to interpret his dreams and was interested in Freudian analysis. Whilst Hitchcock was developing *Spellbound*, the topic of abnormal psychology, guilt by association, and dream theory was very much in the US public consciousness. American servicemen were returning from war haunted by repressed memories and nightmares. Selznick was undergoing psychoanalysis himself and films such as *Since You Went Away* (1944) and John Huston's documentary *Let There Be Light* (1946) explored the lasting effects of trauma on the battlefield.

When conveying dreams, Hitchcock was interested in visual sharpness and clarity in contrast to the foggy and nebulous images associated with dream memory, which was all part of the director's intent to avoid cliché. Furthermore, he was a lover of art, especially modern art, and his favorite painters were Paul Klee, Georges Rouault, Georges Braque, Maurice de Vlaminck, and Giorgio de Chirico. With the latter, he was inspired by Chirico's infinity of distance, long shadows, and converging lines of perspective, which was also part of his background in German Expressionism.

One of the most famous Surrealist painters of the time was the Spanish artist Salvador Dalí. Like Hitchcock, he was interested in making the normal seem strange and uncanny. Dalí was born in Spain in 1904, and studied at the Royal Academy of Fine Arts in Madrid where he became very interested in film and became friends with the director Luis Buñuel. His Surrealist paintings include *The Persistence of Memory* (1931) and *Soft Construction with Boiled Beans* (1936), and evoke the vividness of dreams, with their bright colors, lines of perspective, and symbols of the subconscious. Dalí himself had met Sigmund Freud in London in 1938, and was very interested in how dreams reflect the subconscious, and how multiple images can arise from it, which Dalí called "the paranoiac method."

Dalí was the face of Surrealism in the US and one of the first of the Surrealist painters to achieve such recognition. It was Hitchcock who persuaded his producer David O. Selznick to hire Salvador Dalí to design the dream sequence in *Spellbound*. He said, "[Selznick] probably thought that I wanted [Dalí's] collaboration for publicity purposes. The real reason was that I wanted to convey the dreams with great visual sharpness and clarity, sharper than the film itself."

Hitchcock was keen to replicate the "vividness of dreams" in Dalí's work. He said, "[His] work is very solid and very sharp, with very long perspectives and black shadows. Actually I wanted the dream sequence to be shot on the back lot, not in the studio at all. I wanted them shot in the bright sunshine. So the cameramen would be forced to do what we call stop it out and get a very hard image. This was again the avoidance of the cliché. All dreams in the movies are blurred. It isn't true. Dalí was the best man for me to do the dreams because that is what dreams should be." Dalí's hyperrealistic style was in keeping with Hitchcock's, who wanted to avoid the old style of using Vaseline around the lens and the blurred and hazy screen.

The two men met in the summer of 1944 to discuss *Spellbound*, and Dalí was hired for the sum of $4,000 a couple of weeks before filming began. Dalí was very keen to work in Hollywood and have control over his work, yet the chance to do so had eluded him until Hitchcock's offer. *Spellbound* marked his first association with the American film industry after several failed attempts, including his involvement in *Moontide* (1942), a film noir in which he was asked to create a drunken montage. Legend has it that his sketches were so bizarre and frightening that the film switched to cinematographic techniques to convey the scene.

Dalí was brought in to devise the concept art and storyboards for the dream sequence, especially the four main sequences. Inside the gambling house, he designed the curtain with the eye motifs and other Surrealist references: the two men on the roof, with one of them falling; the ballroom; and the down-hill, up-hill sequence. Dalí tropes such

ABOVE Hitchcock subscribed to Murnau's axiom: "What you see on the set does not matter. All that matters is what you see on the screen." While working as art director on *The Blackguard* for director Graham Cutts, for one scene Hitchcock had hired dwarves to stand far from the camera, creating a forced perspective of distance. He would later repeat this for the ballroom scene in *Spellbound*.

as the cutting of the eye with a pair of scissors are clear references to *Un Chien Andalou* (1929), a short film that Dalí had made with his friend Luis Buñuel where a razor slices an eyeball. "He told me his dream. And I dreamt of a knife cutting an eye. He said we could make a film with that. Using those irrational elements, we wrote the script in seven days. The rule was, refuse any image that could have a rational meaning."

However, when Selznick, who was financing the picture, saw the dream sequence he was extremely disappointed, finding it incomprehensible, and he clashed with Hitchcock over it. To Selznick it lacked the impact he had hoped for given Dalí's name and the cost associated with him, and it may have been too different to sit congruously with the rest of the film. A memo from Selznick states, "It is the photography, set-ups, lighting etc, all of which is completely lacking in imagination."

Selznick turned to trusted colleagues in the hope to salvage what he could. James Basevi was a British-born art director who had started his career designing silent films at MGM. He estimated it would cost $150,000 to realize in full what Selznick wanted to rectify, and the producer was so shocked by the escalating sum that he threatened to scrap the

Spellbound • Chapter 3

47

ABOVE Original Dali design for the truncated end of the dream sequence where John Ballantyne is running downhill. Note the absence of the giant wings and the running man that can be seen in the storyboard sketch by James Bavesi (left). The pliers in the background were to chase Ballantyne back up the pyramid, but were cut from the sequence at the behest of Dr. May E. Romm, David O. Selznick's psychiatrist. Pliers were considered to be a phallic symbol, specifically of castration. © Salvador Dalí, Fundació Gala-Salvador Dalí, DACS 2023.

LEFT The truncated end of the dream sequence where John Ballantyne is running downhill chased by giant wings: "The wings chased me and almost caught up with me when I came to the bottom of the hill."

ABOVE Original Dali design for the dream sequence. Gregory Peck remembered, "There were 400 human eyes which looked down at me from the heavy black drapes. Meanwhile, a giant pair of pliers, many times my size, would appear and then I was supposed to chase him or it—the pliers—up the side of a pyramid, where I would find a plaster cast of Ingrid. Her head would crack and streams of ants would pour out of her face."
© Salvador Dalí, Fundació Gala-Salvador Dalí, DACS 2023.

RIGHT The Surrealist gambling house set based on designs by Salvador Dalí, with hanging curtains painted with staring eyes. Gregory Peck sits in the foreground at a table supported by legs wearing high heeled shoes, another Dalí touch.

sequence altogether. "If the dream sequence should cost anything remotely like this amount, it will have to go out of the picture," Selznick surmised. "I think we need a whole new shake on this sequence, and I would like to get Bill Menzies to come over and lay it out and shoot it," he wrote in a memo.

Selznick once again turned to his production designer William Cameron Menzies, who had designed the sets for *Gone with the Wind* and *Rebecca*. Hitchcock had also worked with Menzies on *Foreign Correspondent* five years ealier, which had a high budget for its time, and at almost $1.5 million was his most expensive film to date. Menzies said he preferred effects "that can only be rivaled in dreams", used camera angles to exaggerate the depths of built sets and was also influenced by German Expressionism.

In describing the role of production designer, Menzies said, "He must have knowledge of architecture of all periods and nationalities. He must be able to visualize and make interesting a tenement or a prison. He must be a cartoonist, a costumier, a marine painter, a designer of ships, an interior decorator, a landscape painter, a dramatist, an inventor, a historical and, now, an acoustical expert". Menzies' storyboards for *Gone with the Wind* are often credited as being a pioneer in live-action cinema, and famed for their lavish set design.

Working with art director James Basevi and set director Emile Kuri, Menzies set about to replan and reshoot the dream sequence with the help of storyboards. Like many art directors, Basevi had been an architect prior to the movies, and worked over the boards based on Dalí's designs. Hitchcock drew his own additional sketches in the margins. Initially the dream sequence was to be twenty-two minutes long, but it was vastly truncated to its final running length of two minutes and thirty seconds.

Dalí's original plan was to have five sequences within the dream: the gambling sequence; the two men on the roof where the owner is killed; the narrator John Ballantyne runs across a barren landscape, and ends up at a dance where he meets Ingrid Bergman's character Dr. Petersen dressed as a goddess, and he kisses her; she then turns into a statue; and the down-hill, up-hill sequence. A number of these scenes were filmed, such as the ballroom sequence, as the production stills illustrate, but later scrapped in post-production.

Menzies re-filmed the Dalí dream sequences while Hitchcock and Dalí were off set. The dream sequence was to be filmed with paintings as backdrops and not sets, to save money at Selznick's request. How much Dalí was involved in the final dream sequence and how much of his influence remained in the final cut has been much debated over the years, fueled by Ingrid Bergman's revelation in an interview that Hitchcock filmed over twenty minutes of dream sequence.

Salvador Dalí scholar Elliott H. King has examined the Selznick archives at the Harry Ransom Center at the University of Texas, Austin, and deduces that Dalí's storyboards and designs were utilized despite the reshoots. He also surmises that much of the dream sequence was in Hitchcock's original script prior to Dalí's involvement.

At the time, David O. Selznick was in psychiatry and his personal psychiatrist was Dr. May E. Romm, who was a pioneer in the field. She served as technical advisor on *Spellbound* while Ben Hecht was writing the script. Certain Surrealist tropes like the eye were trademark Dalí and were well known to both Hecht and Romm and were referenced in the script, including the eyes on the curtains, before Dalí was officially on board as the consultant. The table legs with shoes in the gambling house were direct contributions from Dalí, as were the pianos suspended from the ceiling in the cut ballroom sequence. The pianos are a reference to a script that Dalí tried to film with the Marx Brothers, *Giraffes on Horseback Salad* (1937), which was to be a love story between a Spanish aristocrat and a beautiful Surrealist woman.

Other clear Dalí motifs in the dream sequence are the metronome and the masked face. There are certain paintings by Dalí where the face seems to be melting, such as *Soft Self-Portrait with Fried Bacon* (1941). Dalí scholar Sara Cochran also attributes the film *Les Mystères du Chateau de Dé* (1929) as being influential to Dalí. The film, directed by Man Ray, was filmed in Hyères in France with the help of Charles and Marie-Laure de Noailles, who were huge supporters of Surrealism. The cast wore stockings over their faces so they became anonymous and interchangeable. The Noailles also financed *L'Age d'Or* (1930), a French satirical comedy with a screenplay by Dalí and Buñuel, which was their second collaboration after *Un Chien Andalou*.

By mid December 1944, Dalí was keen to have his mark on the dream sequence and Felix Ferry, his movie agent, contacted Selznick offering to look at the dream sequence for free. As Dalí's nickname

ABOVE Production sketch for Dalí's dream sequence, which starts, "I can't make out just what sort of a place it was. It seemed to be a gambling house, but there weren't any walls, just a lot of curtains with eyes painted on them." The cutting of the eye is a clear reference to the sliced eye of *Un Chien Andalou* from Dalí's work with the Spanish director Luis Buñuel, where one of the most famous images in that film is a woman's eyeball being pulled apart.

was "Avida Dollars", because of his growing fame and financial fortune, his willingness to work for free shows how invested he was in *Spellbound* and becoming successful in Hollywood. The film's production manager Richard Johnston wrote back, "Mr. Selznick is most appreciative of the willingness of Mr. Dalí and yourself to cooperate, and Mr. Dalí's willingness to submit further drawings and suggestions without extra charge."

When *Spellbound* was released, the film was a financial success mainly because of the star power of Ingrid Bergman and Gregory Peck, both of whom had their names above the title. Much talk was made of the dream sequence, which undoubtedly benefited from the streamlining so it stood more as a standalone set piece, expressing the bizarre and irrational. Yet the film portrays madness in a sympathetic light and as something that can be solved. "The analyst seeks only to induce the patient to talk about his hidden problems, to open the locked doors of his mind," says the opening text crawl of the film.

The opening credits state 'Dream sequence based on designs by Salvador Dalí.' Menzies himself didn't want credit for his work, and James Basevi was credited for the storyboards based on Dalí's designs. Basevi himself had won an Oscar® for the art direction of *The Song of Bernadette* (1943) and would later go on to become the art director for John Ford's *The Searchers* (1956). What happened to Dalí's original designs remained a mystery.

Yet many years later Dalí's storyboards would resurface as almost an urban legend. John Russell Taylor, Hitchcock's official biographer who wrote

ABOVE A man walks around the gambling house from the Dalí dream sequence with a large pair of scissors, cutting all the drapes in half. This is a clear reference to Luis Buñuel's *Un Chien Andalou*.

ABOVE The old man with the beard is the real Dr. Edwardes in John Ballantyne's dream who is killed in the skiing accident. Ballantyne deals the seven of clubs. Three of the seven of clubs makes 21, which refers to the 21 Club in New York, where Ballantyne overhears the murder.

ABOVE The dream sequence continues. "He said, 'That makes twenty-one. I win!' When he turned up his cards they were blank. Just then the proprietor came in and accused him of cheating. The proprietor yelled, 'This is my place and if I catch you cheating again, I'll fix you!'" The proprietor is wearing a mask, another Dalí trope reminiscent of the melting faces in some of his paintings.

ABOVE The man in the mask is reminiscent of some of Dalí's previous works, including *Sleep* (1937) and *Soft Self-Portrait with Fried Bacon* (1941). Other Dalí works where masks feature include *Apparition of Face and Fruit Dish on a Beach* (1938), *Old Age, Adolescence, Infancy* (1940) and *Slave Market with the Disappearing Bust of Voltaire* (1940). The melted wheel resembles the melted clocks from *The Persistence of Memory* (1931). The masked man turns out to be Dr. Murchison. The small wheel in his hand is a reference to memory.

Hitch, was teaching film at the University of Southern California in 1976. Taylor went to a garage sale with illustrator Nick Cann in the western section of LA, where they struck upon a remarkable find.

"A bookseller friend of mine found for me somewhere in the Valley nine watercolor gouaches from a storyboard of the Dalí dream sequence in *Spellbound*," wrote Taylor. "Several of them had very sketchy marginal drawings presumably by Hitch himself. I showed them to Hitch, he at once confirmed his hand in them, and identified eight of them as coming from the second, more detailed set, done by art director James Basevi."

There was one storyboard which was from the first series of layouts, and Hitchcock identified it. "But the ninth he immediately recognized as from the first series, mostly done by Dalí himself," Taylor remembered. "This particular one, featuring the tiny, shadowy figure about to scamper across the mysterious intersecting pyramids, he remembered particularly because Dalí suddenly said, 'Why did I do that? The angle of that pyramid is quite wrong,' and immediately repainted it himself."

"I was surprised that [Taylor] bought those and I wondered why he bought them," remembers Nick Cann. "And of course one turned out to be Salvador Dalí. They were about fifteen by twenty inches and [there were] many of them."

Whoever put them in the garage sale didn't know one was an original Dalí. In 2023, John Russell Taylor still has the Dalí storyboard that he found, framed in his London home. There's every chance that other original Dalís from *Spellbound* are still out there waiting to be discovered.

BELOW A man falls to his death. Production designer William Cameron Menzies sketch done over a photograph of a Dalí painting. The roots of the trees growing into the building is another Dalí motif.

18

 I knew he was going to fall but I
 couldn't do anything. Then he went
 over - slowly - with his feet in the
 air.

CAST AND CREW

James Stewart
Scottie Ferguson

Kim Novak
Madeleine/Judy

Barbara Bel Geddes
Midge

Tom Helmore
Gavin Elster

Henry Jones
Coroner

Raymond Bailey
Scottie's Doctor

Ellen Corby
Hotel Manager

Konstantin Shayne
Pop Leibel

Director
Alfred Hitchcock

Screenplay
Alec Coppel & Samuel Taylor

Story
Pierre Boileau & Thomas Narcejac

Cinematography
Robert Burks

Film Editing
George Tomasini

Art Direction
Henry Bumstead & Hal Pereira

Associate Producer
Herbert Coleman

Unit Production Manager
C.O. Erickson (uncredited)

Art Department
Al Lowenthal (Illustrator; uncredited)

Titles Designer
Saul Bass

Special Sequence
John Ferren

Chapter 4

VERTIGO

"I have acrophobia, which gives me vertigo, and I get dizzy."

— Scottie Ferguson, *Vertigo*

PLOT SUMMARY

Detective Scottie Ferguson and a policeman chase a criminal over the San Francisco rooftops. When Scottie slips, the policeman comes to his aid but falls to his death and Scottie is stricken with acrophobia, a fear of heights which leads to vertigo. Some time after, Scottie, now retired from the police force, is asked by old college friend Gavin Elster to follow his wife Madeleine. Scottie follows the mysterious Madeleine around San Francisco, eventually rescuing her when she tries to drown herself in the bay. She says she has recurring nightmares and is haunted by the spirit of her great-grandmother Carlotta Valdes, whose portrait hangs in an art gallery. Midge, an ex-girlfriend of Scottie's, tries to make light of the situation but Scottie has fallen too deeply in love with Madeleine. When she tells Scottie about her latest dream, he takes her to San Juan Bautista Mission. In another fit of aberration, Madeleine throws herself off the bell tower and a guilt ridden Scottie is unable to save her. After the inquest, which rules suicide, Scottie has a breakdown, is confined to a mental institution and is unable to be consoled by Midge. Some months later, still haunted and depressed, Scottie meets another woman, a shop girl named Judy, who strongly resembles Madeleine. Scottie sets about remaking the image of his lost love, forcing Judy into wearing the same clothes and hairstyle as Madeleine. When Judy puts on Carlotta's necklace, Scottie realizes he has been set up by Elster, and that Judy was his girlfriend. He takes Judy back to San Juan Bautista Mission where she confesses she was an accomplice in Elster's scheme to kill the real Madeleine by throwing her off the bell tower. When a nun appears like a ghostly apparition, Judy panics and falls to her death, leaving Scottie to look down as he overcomes his vertigo.

FROM AMONG THE DEAD – INT. BELL TOWER

STAGE SET

"VERTIGO" HENRY BUMSTEAD ART DIR.

Vertigo is considered by many to be Hitchcock's masterpiece, a haunting tale set in San Francisco about romantic love and the illusion of memory. The story was filmed on location in San Francisco in the late summer of 1957, followed by studio filming at Paramount in Los Angeles, with film stars James Stewart and Kim Novak as the leads. The Salvador Dalí dream sequence in *Spellbound*, the out of control carousel in *Strangers on a Train* (1952), and the trouble of disposing of a corpse in *The Trouble with Harry* are just a few of the vivid dreamlike images in Hitchcock's films leading up to *Vertigo*. They are all portrayed so vividly, yet seem fantastic, like waking nightmares. Even *Vertigo*'s working title, *From Among the Dead*, translated from its French source novel *D'entre les morts*, by Pierre Boileau and Thomas Narcejac, sounds like a fantastic nightmare.

For the avant garde title sequence, Hitchcock hired graphic designer Saul Bass, who would play a bigger role in *Psycho*. A big close-up on a woman's eye starts *Vertigo*'s opening credits, echoing the eyes in the Salvador Dalí dream sequence in *Spellbound*. There are also other Dalí-like references, such as the falling figure from the bell tower, reminiscent of the man tumbling from the rooftop in *Spellbound*. Just like the Dalí dream, *Vertigo* has its own nightmare sequence for which Hitchcock collaborated with artist John Ferren from the New York School, who also created the artworks for *The Trouble with Harry*. The whole of *Vertigo* was carefully storyboarded by one of Hitchcock's most trusted production designers, and the resulting work would help *Vertigo* to be cited as the number one film of all time by a panel of critics.

ABOVE Production illustration for the bell tower, which was carefully storyboarded, and a set was made for the forced perspective showing the illusion of vertigo. Gavin Elster waits at the top for Judy, pretending to be Madeleine, so he can throw down the body of his real wife—whose neck he has broken—to convince Scottie that she had fallen to her death.

HENRY BUMSTEAD

Henry Bumstead, known to his friends and colleagues as "Bummy", was born in 1915 in Ontario, Southern California. From a young age, he was a talented artist and excelled at drawing. At the age of six, he drew a horse and had the anatomy and motions of the horse down very well. From an early age he wanted to be a cartoonist. His natural strengths were drawing and lettering but he was also very interested in sport, becoming the high school football team captain, and was granted an athletic scholarship to attend the University of Southern California.

Just like Dorothea Holt and Robert Boyle, Bumstead studied architecture at the University of Southern California, which was the only such program of repute on the west coast. When he graduated it was the height of the Depression, and unlike some of his classmates who became lawyers, Bumstead opted for the more lucrative film industry. Bumstead started at Paramount in 1937, when Hans Dreier was head of the department. Dreier was from Germany, had worked at UFA studios, and was known for his Paramount films such as *A Farewell to Arms* (1932), *Shanghai Express* (1932), and *Cleopatra* (1934).

The illustrators were called draughtsmen rather than storyboard artists, and there were about eight to ten working in the drafting room at Paramount, working on construction drawings for the sets. Bumstead was the youngest. His work involved sketching, making models, and overseeing set construction together with the art director. For Bumstead it was great training as everything was done on the lot. Bumstead would make drawings of the sets and give them to the draughtsman to make working construction drawings.

Just like Hitchcock's notion of a clear horizon, Bumstead's favorite part of starting a new film was with the blank piece of paper. He enjoyed nothing more than to read the script, take a blank sheet of vellum, and start designing the first set. He would lay that out, not in an architectural sketch but in floorplans first, in one-quarter scale. Most set drawings were done at quarter inch to the foot, then to three quarter inch, then to full size. At Paramount the draughtsmen often worked at half inch to a foot scale and then went from half inch to full size. Bumstead's skills were in draughting and

ABOVE Storyboard for the scene following Muir Woods, in which Scottie drives Madeleine to Cypress Point and then observes her along the rocky beach.

Sc. 185E Madeleine and Scottie play scene at cypress tree. Transp. plus studio set. Madeleine turns and exits scene.

Sc. 185F Madeleine running toward the edge of the land. Scottie following. Location with doubles.

Sc. 185G Scottie catches her and holds her. Location with doubles.

Sc. 185H Madeleine and Scottie play scene The wind blows and the waves dash up against the rocks throwing up a curtain of spray. Transp.

FROM AMONG THE DEAD

ABOVE Second storyboard (following on from that on page 57) for the scene following Muir Woods where Scottie chases Madeleine along the rocky beach at Cypress Point.

elevations and designing, and the results would then go to an illustrator.

"In those days, it was a few weeks to make drawings, and two or three weeks to construct the set and give the decorators time to dress it," said Bumstead. "We could work that fast because all the facilities were on the lot, and the decorators were so talented and wonderful." He used a carbon pencil to sketch, and would smear his drawings with a brush or cotton, picking up highlights with an eraser, and when designing production illustrations would add watercolor to them.

At the time, Paramount didn't have big drafting rooms, and there were only two artists working in a room; Bumstead was in a room with Walter Tyler, while Boyle was sharing another room with Al Nozaki, which is how they all got to know each other, working together at the studio. There were only eighty art directors at this time in Hollywood; in 2023 there were around three thousand members in the guild.

Whilst at Paramount, Hitchcock was looking for a production designer for his remake of *The Man Who Knew Too Much* and he asked his cinematographer Robert Burks if he knew of any young art directors that he would like to work with. Burks said he was working with one at the moment,

Henry Bumstead, on *The Vagabond King* (1956), and introduced him to Hitchcock. Never in his wildest dreams did Bumstead think he would be working with the famed Master of Suspense. Working with the director was challenging, because he had the entire film thought out in his head since he had been an art director himself; Bumstead, despite his obvious talent, always felt insecure working with Hitchcock, saying, "I'm gonna get fired!"

Bumstead spent much time in Marrakech planning the exteriors for *The Man Who Knew Too Much* (1956) and getting enough photos for the interior sets, particularly sourcing the Moroccan tiles, rugs, and mosaics for authenticity. Along with production manager C.O. 'Doc' Erickson and associate producer Herbert Coleman, Bumstead became a regular member of the Hitchcock crew at Paramount, and was one of the director's "favorite people," as Erickson recalled.

When planning for *Vertigo*, Hitchcock showed Erickson and Coleman the French novel *…D'entres les morts*. They were both very pleased because they thought they would be filming in France again, having spent time on location for *To Catch a Thief* on the French Riviera in 1954. As Erickson remembers, Hitchcock had been "Pleasant to work with, no one could top him. It was a joy, he was

a great storyteller and good to be around." On a production level, Hitchcock knew what he wanted and made it clear.

As the production manager, Erickson was concerned with the physical and operational workings of the sets. He was tasked along with Coleman and Bumstead to scout locations in and around San Francisco for the many settings which Hitchcock had in mind. "He was a master of composition, using the camera and the actors' movements to relay the importance of the story he was trying to tell. Hitchcock preferred sitting right under the camera lens so he was looking at the actors and their relationship to one another, seeing it the way the camera saw it. I always thought that was interesting and important to him," said Erickson.

During the preproduction of *Vertigo*, Bumstead showed Hitchcock six or seven sketches of the sets he designed, working with illustrator Al Lowenthal, based on Bumstead's rough sketches. These included architectural set plans, using graphite pencil on 58 inch by 42 inch tracing paper. "Those of us at Paramount did more detail work than those at some of the other studios. But also I was just brought up that way, to be aware of so many things, such as texture and aging, for instance."

Over fifty sets were built for *Vertigo* based on Bumstead's set drawings with full scale details. These included Scottie's apartment, Midge's apartment, Gavin Elster's office, Ernie's restaurant, the San Francisco club where Scottie and Gavin meet, the flower shop and dark passageway, the McKittrick hotel, the bell tower and interior of San Bautista, a beauty salon and department store, and Judy's hotel room and hall at the Empire Hotel. As in any Hitchcock movie, they strove to make the sets and backgrounds as realistic as possible. A set dresser would then come and dress the set, working with the prop man.

Hitchcock used sets for *Vertigo* which looked like actual rooms. Back then Bumstead was required to draw architectural styles and details, more so than today, which is more location-bound. "One thing I really admired about [Hitchcock] was that whatever you built, he really shot. He just didn't get in a corner and shoot. He used sets well. He shot every bit of your set," recalled Bumstead.

When it came to set designing, Hitchcock and Bumstead were a match made in heaven. The authenticity of the design and furnishings were important to both in their quest for realism combined with good taste. Hitchcock was very conscious that many films had an artificial look because the sets were dressed badly, most of the time a result of the dresser's lack of knowledge of the character who lived in a particular room. One way that Hitchcock overcame this was to send a photographer with a color camera to take stills, which he did for *Vertigo*. Similarly, Bumstead would research the characters who lived in his sets, and the designs for Scottie and Midge's apartments, as well as Gavin Elster's office and club, are rich in character and historical detail.

ABOVE One of Henry Bumstead's sketches for the famous bell tower sequence, where Madeleine seemingly commits suicide by throwing herself off the top. This drawing is a plan and elevation of the church tower. The elevation includes a figure falling from the top of the tower.

DESIGN FOR CHARACTER

When designing Scottie's apartment, Hitchcock drew an original sketch which Bumstead used to base his design on. "What I learned from Hitch, I carried out my same theme of making sets look like the people that lived there," Bumstead said. "He liked to see what people do in that room."

In *Vertigo*, Scottie is a retired detective and a bachelor nearing fifty, whose engagement with Midge was broken off after two weeks. He wouldn't have had a lot of bookcases, because as a detective he seldom had time to read. Bumstead was aware of this, as he had previously designed a beautiful apartment for a character and to save money had lined it with bookshelves—the type of place he always wanted to have himself in New York. Hans Dreier stopped by to watch him work, and looking at the bookcases said, "Oh, he's a very learned man, isn't he?" Bumstead was dumbstruck, and later asked him what he meant. Hans said, "If he's not a learned man, why the books?" Bumstead learned from that. He blushed deep red and learned his lesson right then and there and tore out all the bookshelves.

At the time Bumstead was a stamp collector, so he thought he would give the same hobby to James Stewart's character. Even though the stamp collecting isn't obvious in Stewart's apartment, the fine detail can be seen in the background desk after Scottie rescues Madeleine from the bay, and the camera slowly pans from him sitting in the living room to his bedroom where she is recovering. Hitchcock appreciated those fine character details, because it showed the production designer having a good sense of the script and adding to the character. Bumstead's point was to try and design sets that look like the characters that live in them: If your character is a simple man, make it a simple set.

The production team also sought an exterior location for Scottie's apartment and Hitchcock would say, "Bummy, make sure that the exterior shot has Coit Tower in it because it's a phallic symbol." He was very specific in that. They chose an apartment at 900 Lombard Street in San Francisco with a view of Coit Tower from the exterior.

As well as designing for character, one of Bumstead's key strengths was his attention to the aging of sets. "I think Paramount did a marvelous job on aging of all our sets, and I think I became very aware of aging. Look at a fireplace, how does it age around doorhandles, how does the bottom of the door age when it's kicked? Today, many of the sets don't look lived in," recalled Bumstead. The authenticity and design of a character's set was something that Hitchcock was very adamant about. Later on, when Hitchcock trusted Bumstead, Bumstead would recall saying, "'Hitch, you've got to come out and look at this set,' and Hitch would say, 'Why should I come and have a look at this set? Isn't Bummy a professional?' and he left it like that."

Bumstead also designed shipping magnate Gavin Elster's office, with rich oaks and dark wood, evoking memories of the past. Although Hitchcock had final say, all those little touches were Bumstead's idea and helped define character. So pleased was Hitchcock with Bumstead's work on *Vertigo*, he also asked him to design paneling in his Brentwood house as well as fixtures for his weekend retreat in Scotts Valley near Santa Cruz.

OPPOSITE TOP Production illustration detailing Scottie's apartment, based on Hitchcock's original sketches. The view of the phallic Coit Tower can be seen through the window, which was a very important detail for the director. Graphite on paper 21" x 20.25"

OPPOSITE Storyboards for the sequence where Scottie follows Madeleine to Fort Point under the Golden Gate Bridge where she pretends to drown herself in the bay.

FROM AMONG THE DEAD - INT. SCOTTIE'S APT.

Sc. 132 LOC. EXT. FORT POINT - Pan Scottie's car to stop. The green jaguar stand ahead. Madeleine getting out of car.

Sc. 133 LOC. Scottie gets out of his car and looks off out of picture.

Sc. 134 LOC. Madeleine walking away. Scottie moves into f.g. Madeleine disappears round corner of old fort wall. Scottie quickens his pace as he approaches wall.

Sc. 135 LOC. Scottie approaches wall- peers cautiously around S.F. in b.g.

Sc. 136 LOC. Scottie's viewpoint - Madeleine standing at water's edge - tearing off paper from nosegay.

Sc. 137 LOC. Scottie watching her cautiously.

Sc. 138 LOC. Madeleine begins to scatter the flowers on the water.

Sc. 139 STUDIO TANK - close shot of flowers floating on the water.

Sc. 140 LOC. Scottie watching Madeleine

Sc. 141 LOC. Madeleine jumps into water

Sc. 142 LOC. Scottie dashes around the wall and camera pans him to water's edge and top of stairs.

Sc. 143 STUDIO TANK - Shooting down into water we see Madeleine's up- turned face.

Sc. 144 SET STUDIO - Scottie exits down steps out of shot.

Sc. 144A SET STUDIO TANK - Shooting down toward water - Scottie enters water and swims out of shot.

Sc. 145 STUDIO TANK Scottie swims into shot and grabs Madeleine.

Sc. 146 STUDIO TANK Scottie holds Madeleine and swims out of shot with her.

FROM AMONG THE DEAD

Sc. 147 SET STUDIO TANK Scottie starts up stone steps with Madeleine.

Sc. 148 LOC. Scottie comes to top of steps and exits shot.

Sc. 149 LOC. Scottie opens door of jaguar.

Sc. 150 LOC. After dialogue camera moves in until Madeleine's head fills screen.

"VERTIGO" HENRY BUMSTEAD - ART DIR.

OPENING CHASE SCENE

Like many of Hitchcock's films, *Vertigo* has a memorable opening. An exciting chase sequence starts the film, as a uniformed policeman and plain-clothes detective Scottie Ferguson pursue a criminal across the San Francisco rooftops at dusk. Moments later, Scottie slips and is hanging onto a gutter, unable to pull himself up as he is overcome with vertigo. The policeman offers his hand but slips and tumbles to his death. Hitchcock wanted an exciting opening chase for *Vertigo*, which resembles a nightmarish pursuit and sets the scene for the rest of the movie.

"Well, the opening scene was so important in *Vertigo*," Bumstead remembered. "In every picture Hitch had one thing that he was really adamant about, and [in *Vertigo*] that was the opening of the picture where they're running across rooftops."

The opening image of the stable horizontal bar, revealed to be the rung of a ladder, establishes the film's motifs and composition of horizontals and verticals. The verticals are later visualized in Coit Tower in San Francisco, the struts of the Golden Gate Bridge and the bell towers of Mission Dolores and San Juan Bautista; while the horizontals can be found in Scottie's and Midge's apartment designs, the span of the Golden Gate and Bay Bridge and Scottie's balancing stick as he ascends the step ladder in an attempt to cure his vertigo. This intersection of horizontal and vertical would reach their zenith in Hitchcock's *Psycho*, especially the Saul Bass-designed opening credits.

Hitchcock's film crew, Bumstead, Burks and associate producer Coleman, first looked at several places in Los Angeles to film the rooftop chase. "That sets up the whole picture, that vertigo," remembered Bumstead. "At that time, because of earthquakes, the tallest building in Los Angeles could be, I think, ten storeys high. We tried to put a bridge across and tried it, and it was absolutely nothing. I think that building [in the film], full sized, would have been about fifty storeys high." The buildings gave no feeling of real height, which was essential, so the crew turned to San Francisco for their location.

Cinematographer Burks and Coleman filmed the rooftop chase scene in San Francisco on August 26th 1957. They waited for magic hour, that period when the sun is very low in the sky, giving long shadows and the perfect light. The phallic Coit Tower was in the background along with the Bay Bridge. When twilight came, they filmed the long shots for fifteen minutes between 7.50 to 8.05pm. Just over two weeks of location filming in San Francisco took place at the end of August and September 1957.

James Stewart's close-ups were filmed on Stage 5 of Paramount Studios on the second to last day of principal photography. But they still had to visualize the vertigo effect and Scottie's POV when he slips and looks down to his impending doom, and later when he chases Madeleine up the bell tower but is unable to save her from her apparent suicide. Scottie slips and falls and his POV of the street below is agonizingly conveyed through the use of forced perspective; and for that Hitchcock dug deep into his experience of German Expressionism. He was very keen to convey subjective feelings and would use all his cinematic grammar so that the audience would not just see but feel what the characters were going through.

OPPOSITE Storyboard for the opening chase sequence where Scottie slips chasing a criminal over the San Francisco rooftops and a cop comes to his aid.

5 - Scottie's Viewpoint - Gap Trebles its Depth S.P.D.

6 - Nausea Overcomes Scottie - Set plus Transp.

7 - Policeman Returns - Fleeing Criminal in the Distance - Set plus Transp.

FROM AMONG THE DEAD

PARAMOUNT PICTURES CORPORATION ART DEPARTMENT

"VERTIGO" HENRY BUMSTEAD - ART DIR.

FORCED PERSPECTIVE

While at UFA studios in Germany in the 1920s, Hitchcock was greatly influenced by F.W. Murnau's film *The Last Laugh*, particularly the use of forced perspective and depth of field while he was filming a railway carriage in the distance and outside a hotel. "I was able to absorb a lot of the method and style," remembered Hitchcock. He was also influenced by the work of Arthur Robison and Karl Grune, who made *The Street* (1923).

Forced perspective is a technique to give the illusion of depth on a set in which the scale is not constant. There might be one scale in the foreground gradually diminishing to another scale in the background. The elements further away are supposed to look very distant and are rendered in even more diminished scale, while foreground elements are in full scale. The purpose is simple: to get more set into a smaller space. It can be a tremendously effective technique.

Hitchcock's team of Robert Burks and Henry Bumstead designed a shot of 'forced perspective' to convey Scottie's fear of vertigo. Bumstead drew upon a thirty-percent rule with forced perspective, which he knew from his architectural training; "Then I realized that I had to do a forced perspective... So that set up the whole deal for the picture (the believability of Scottie's incapacitating vertigo). It got the effect that Hitch wanted, and he was very pleased with it."

On storyboard 15 in the opening chase sequence, which shows Scottie's POV with his legs dangling in the air, is written 'Forced Perspective'. Later it is twice used during the famous chase up the bell tower: first when Scottie pursues a suicidal Madeleine but is unable to prevent her from throwing herself off the top and during the film's climax, when Scottie drags a reluctant Judy and overcomes his vertigo to make it to the top.

Hitchcock also said that he derived the idea for the vertigo effect from one night at the Chelsea Arts Ball in London in the 1930s. He had too much to drink and in the early hours of the morning

ABOVE AND OPPOSITE TOP First sequence storyboard for the opening chase over the San Francisco rooftops where the cop reaches out to Scottie, who is stricken by vertigo and unable to extend his hand. The cop slips and falls to his death.

12-Scottie Hears Wild Cry - Set plus Transp. Policeman falls through shot Behind Scottie

13-Policeman Falling Thru Space - S.P.D. FROM THE DEAD

everything seemed to be getting farther and farther away from him. The effect remained in his mind and when he moved to the US he wanted to replicate the memory for *Rebecca*. During the coroner's inquest, the second Mrs. de Winter is supposed to faint, and Hitchcock wanted the effect of everything receding from her, but wasn't able to pull it off, despite trying techniques such as printing a photograph on rubber and stretching the middle. Some eighteen years later, when he was in pre-production for *Vertigo*, he remembered that effect and thought it would be splendid in visually interpreting Scottie's fear of heights.

Hitchcock was also influenced by the Italian Surrealist painter Giorgio de Chirico and his converging lines of perspective in such works as *The Mystery and Melancholy of a Street* (1914), which is apparent in the photography of San Juan Bautista Mission. Forced perspectives are used in other Hitchcock films, most notably in *Marnie*, when Marnie remembers her traumatic past, and also the (scrapped) ballroom scene of the dream sequence in *Spellbound*.

BELOW Second sequence storyboard marking the forced perspective that gives the feeling of vertigo. The working title for the production was *From Among the Dead*.

14-Scottie Stares Down in Horror - Set Set plus Transp.

15-Policeman Sprawled on Ground - People Stare at Body and Look up to Scottie - S.P.D. FROM AMONG THE DEAD

65

FILMING THE BELL TOWER

When searching for a bell tower, which is pivotal to *Vertigo*'s murder plot, Bumstead and Coleman looked at Spanish missions within driving distance of San Francisco. A mission in Carmel was considered but discarded as it was too touristy. But when Coleman went to visit his daughter Judy, who was studying nearby at San Jose State University, he was provided with the perfect location.

"I was at college mostly at this time," remembers Judy, who was earning a teaching degree in San Jose. She knew of and recommended San Juan Bautista, about a hundred miles south of San Francisco near the town of Salinas, yet remote enough to be just off the tourist trail.

Founded in 1797, the mission later had a steeple added which was destroyed by a fire, so Bumstead and the production crew had to paint in the bell tower with a matte painting for the long shots, and a seventy foot high set was constructed on Paramount's stage 5 for James Stewart and Kim Novak to ascend.

"Of course, I enjoyed designing the church tower and steps leading up to the bell tower," recalled Bumstead. "You know you could never get Hitch to go and look at a set, and the bell tower was completed. So I asked Herbie Coleman, the associate producer, to bring Hitch over." Hitchcock's typical response again was, "Isn't Bummy a professional? So why do I have to go look at it?" So often Bumstead was nervous whether his sets would be approved by Hitchcock, but a bigger challenge was creating the vertigo shot within the bell tower.

Hitchcock consulted with his technical department on how to achieve the vertigo effect in the bell tower and was quoted $50,000 because the film crew would have to assemble an overhead rig above the staircase on the set to take the camera up as the lens zoomed forward. When Hitchcock asked why, the crew told him, "Because to put the camera at the top of the stairs we have to have a big apparatus to lift, counterweight it, and hold it up in space."

As Hitchcock explained, there were no characters in the scene, it was simply a viewpoint from James Stewart's character. "The viewpoint must be fixed, you see, while the perspective is changed as it stretches lengthwise. I thought about the problem for fifteen years. By the time we got to *Vertigo*, we solved it by using the dolly and zoom simultaneously."

The solution was to make a miniature of the stairway and lay it on its side, then film a shot by pulling away from it using a tracking shot and a zoom

ABOVE Storyboard sketches for Madeleine running up the bell tower with Scottie in pursuit. The set of the bell tower stairs showing the forced perspective and the illusion of vertigo was a miniature.

OPPOSITE Watercolor for the San Juan Bautista Mission, which is the setting for two killings, first Madeleine and then accidentally Judy. The bell tower was painted in as a matte as the original steeple had burned down in a fire.

flat on the studio floor. "So that's the way we did it, and it only cost us $19,000," said a very pleased Hitchcock.

This Dolly Zoom was invented by cameraman Irmin Roberts, and was achieved by zooming in with the lens while dollying backwards. The effect distorts the visual perspective, with the background appearing to change in size relative to the subject. Hitchcock creates a tremendous feeling of distortion and fear by increasing the shot angles, which underscores Scottie's failure to reach Madeleine, and emphasizes his vertigo, unbalancing the viewer.

The large scale model of the staircase lying on its side on the studio floor was filmed by special effects cameraman John Fulton. The vertigo shot, a zoom in and a dolly back, causes the image to stretch with the forced perspective and the illusion of the background suddenly moving farther away from the camera, while the foreground remains the same. It also became known as the Dolly Zoom, the Zolly and the Hitchcock Zoom. It was $19,000 put to good use—as the shot is an indelible stamp which has been replicated by other directors from Steven Spielberg to Martin Scorsese.

In the scene when Scottie drags Judy up the bell tower at the end of *Vertigo*, Hitchcock was very specific about the timing of each of the shots. "Going up the stairs, we worked out the length of the shots with the metronome, so we were getting the rhythm of going up the stairs as he wanted, that was very important to him," remembers Kim Novak.

Hal Pereira would later replace Hans Dreier as head of the art department, which is why he is credited on Hitchcock's Paramount films from *Rear Window* to *Vertigo*, but he was very much an overseer of the department, with Bumstead doing most of the work. Bumstead's hard work paid off, as he was awarded his first Oscar® nomination for *Vertigo*.

Paramount's art department would later close down in the 1960s, but Bumstead had moved on by then to Universal during the actor's strike in 1960. He was given more money and a four-picture deal, and won two Academy Awards® for *To Kill a Mockingbird* (1962) and *The Sting* (1973).

At Universal, he would end up working on a further two films with Hitchcock, *Topaz* and *Family Plot*, but it was his work on *Vertigo* for which he would best be remembered. He even designed a prop called a Bummystone, named for one of the patterns of fiberglass stone panels for set construction.

CAST AND CREW

Cary Grant
Roger O. Thornhill

Eva Marie Saint
Eve Kendall

James Mason
Phillip Vandamm

Jessie Royce Landis
Clara Thornhill

Leo G. Carroll
The Professor

Josephine Hutchinson
Mrs. Townsend

Philip Ober
Lester Townsend

Martin Landau
Leonard

Adam Williams
Valerian

Director
Alfred Hitchcock

Screenplay
Ernest Lehman

Cinematography
Robert Burks

Film Editing
George Tomasini

Production Design
Robert Boyle

Art Direction
William A. Horning & Merrill Pye

Set Decoration
Henry Grace & Frank McKelvey

Associate Producer
Herbert Coleman

Titles Design
Saul Bass

Art Department
Mentor Huebner (Storyboard Artist; uncredited)

Chapter 5

NORTH BY NORTHWEST

"The Hitchcock picture to end all Hitchcock pictures."

— Ernest Lehman, screenwriter

PLOT SUMMARY

Roger O. Thornhill is a New York advertising exec, with a secretary, two ex-wives, a mother and several bartenders who depend on him. He's mistaken for a secret agent named George Kaplan and taken by two heavies to the Long Island house of Lester Townsend, where he is interrogated by Phillip Vandamm. After resisting a drunk drive charge, Thornhill seeks out Townsend in the United Nations building to try and discover the identity of his kidnappers, but he is wrongfully accused of stabbing him in the back. Now on the run, Thornhill boards the Twentieth Century Limited train to Chicago, where he meets the mysterious Eve Kendall. After spending the night with her, she sends him to a remote prairie stop where he will meet the real George Kaplan. Instead, he is attacked by a cropduster in an attempt by Phillip Vandamm and his heavies to kill him. He narrowly escapes and seeks out Eve, who is working with Vandamm, in her Chicago hotel, following her to an auction house where they are bidding for a pre-Columbian statue. Thornhill escapes being caught again by getting himself arrested and is released by the Professor, who says that Eve is a double agent working for the US Government. Eve pretends to shoot Thornhill in the Mount Rushmore café and later reveals to him she has to leave the country with Vandamm to keep up the ruse. Thornhill tracks her to Vandamm's house high above Mount Rushmore and tries to warn Eve after henchman Leonard informs Vandamm that Eve used blank bullets. Thornhill and Eve escape with the pre-Columbian statue that contains important microfilm, and are chased by Leonard and Valerian. The heavies are killed, Vandamm is arrested, and Thornhill and Eve spend their honeymoon on the Twentieth Century Limited.

A lone cropduster appears out of the sky and slowly descends towards a man wearing a gray business suit, alone and exposed, standing at a prairie stop. The biplane comes closer and closer until the man realizes that he is being targeted and a hail of gunfire follows him. He runs like a jackrabbit and seeks refuge in a crop field.

The cropduster sequence is one of the most famous action montages in Hitchcock's work and indeed in cinematic history. The many complicated set pieces of a man on the run, such as the cropduster sequence and the escape onto the faces of Mount Rushmore, involved careful storyboarding to coordinate the camera and actors.

These storyboards also included the Grand Central Station sequence, the Vandamm house, with plans showing the various camera angles, as well as artwork consisting of three sketches of the Glen Cove estate, where Roger Thornhill is taken to meet Phillip Vandamm. The largest of the sketches shows the layout of the house and includes details of the entryway. Architectural set plans were also designed for the terminal building, phone booths, a cafeteria near Mount Rushmore, an office building lobby, the Clarke Panay gallery, the lobby at the United Nations, the Vandamm living room, Eve's hotel room, a train club car, a men's room, and exterior drawings for the cornfield bus stop, trees, and a stone wall. Many of these involved matte shots and paintings for economy, for example when Roger Thornhill runs out of the United Nations building after the stabbing of the delegate: the high overhead shot is a matte painting, as is the high shot of the cornfields when Thornhill is dropped off by the bus at the prairie stop.

As always, Hitchcock was very concerned about the authenticity of settings and furnishings, such as the delegates' lounge of the United Nations in New York. So he and his assistant disguised themselves as tourists and took photographs, and then recreated the lounge on a soundstage. The shot of Cary Grant entering the United Nations from outside was taken surreptitiously with a camera hidden inside a van.

The wrongfully accused man is a characteristic Hitchcock trope, and Hitchcock and his screenwriter Ernest Lehman devised a *North by Northwest* trajectory from New York to Chicago and then to South Dakota and Mount Rushmore, which has the climactic scene of Roger and Eve clambering on the Presidents' sculpted faces. Lehman wrote on index cards an idea of the structure and developed that into an original screenplay, which crackles with sophistication and panache.

As in all of Hitchcock's preproduction, the main thrust of his work was preparation and storyboarding. In that regard, he was reunited with a first-rate production designer, Robert Boyle, who created the iconic set designs for Mount Rushmore as well as finding the location for the cropduster sequence, and these storyboards were illustrated by artist Mentor Huebner. Hitchcock's preparatory method complemented the expertise of those who worked with him. As Boyle remembered, "Matter of fact, he sometimes facetiously said he was bored with shooting the picture. The excitement came with the ideas that were generated in the preparatory portion of the filmmaking process. He liked to have it all clear in his mind so that before he started to shoot, he saw the whole movie in his mind. There are very few people, directors or otherwise, that can hold this kind of a concept."

LEFT The very empty prairie stop at the beginning of the cropduster sequence where Roger Thornhill is dropped off. The cornfield in the distance was also a matte painting combined with the crane shot.

ROBERT BOYLE

One of Hitchcock's favorite production designers was Robert Boyle, who worked on five films with Hitchcock—*Saboteur*, *North by Northwest*, *The Birds*, *Marnie*, and *Family Plot*. Other films he became famous for include *The Thomas Crown Affair* (1968) and *Fiddler On the Roof* (1971). Born in Los Angeles in 1910, Boyle graduated from the University of Southern California with a degree in architecture, alongside art director Al Nozaki, having attended the same school of architecture as Dorothea Holt and Henry Bumstead. When Boyle graduated it was the height of the Great Depression, and he couldn't find many architectural firms to work for. When he did find work, three different architectural firms who employed him all folded as soon as he got a job. But the studios at the time were booming. "Fantasy land was at its height, and that's where we got our jobs," remembered Boyle. Hollywood was the place to live one's dreams and studios like MGM were fantasy lands, where everybody on the screen was rich. Most people sought escapism by going to the movies.

ABOVE Robert Boyle, who first worked with Hitchcock as associate art director on *Saboteur* and *Shadow of a Doubt*, as well as being the production designer for *North by Northwest*, *The Birds*, and *Marnie*. Courtesy of Emily Boyle.

Van Nest Polglase, an art director at RKO, asked to see some representative sketches of his work. Working through the night, Boyle drew what he thought movie sets looked like. The following day, Polglase phoned up Paramount studios and on his recommendation Boyle gained a job as a draughtsman, working his way up, mostly as a sketch artist, gaining experience in illustration, continuity sketching, and then following it up with working on the sets. Boyle's sketches were, as he described them, "scribbles" with charcoal. He also worked as a storyboard consultant for producer Henry MacRae, who made serials at Universal, such as *Don Winslow of the Navy* (1942). During this period, Boyle had also been associate art director on *The Wolf Man* (1941).

When Hitchcock was preparing *Saboteur* in 1941, he said what he really needed was a sketch artist. Boyle, meanwhile, had been persuaded by a friend to join Universal, where he worked for supervising art director John Goodman. So it was at Universal where Boyle began his association with Alfred Hitchcock and in his first big movie was credited as associate art director. From Boyle's standpoint, the project started with reading the script, so that the production designer identifies with the characters. "Really the art director is a contributing factor and aids the director in getting what he really wants out of the whole film," Boyle said. "The production designer is responsible for the space in which the film takes place, the environment within which the action and the meaning of the film takes place."

"[Boyle] was brilliant at what he did and did not suffer fools lightly—and a lot of people were terrified of him, because he could be very blunt. He knew what he wanted and what Hitch wanted," remembers fellow production designer David Snyder. Boyle sat in the production meetings with Hitchcock and screenwriter Ernest Lehman, and the writing of *North by Northwest* took almost a year, as the three went through the description of every shot and every scene. Hitchcock had the big office at the end of the hall; next to his office was Lehman, the writer; Boyle had the office next to Lehman; and cinematographer Burks was next to Boyle. "The reason we had storyboards and it was all preplanned was that not only was it easier for [Hitch], but he had already been able to communicate all the other disciplines involved," said Boyle.

MENTOR HUEBNER

When designing the storyboards, sketches, and production illustrations for *North by Northwest,* Boyle worked with artist and production illustrator Mentor Huebner. Huebner was born in Los Angeles in 1917, and after attending Eagle Rock High School he started a scholarship at the Chouinard Art Institute in LA. This is where Walt Disney encouraged his animators to attend Friday night classes, and it would produce the crop that drew the designs for *Snow White and the Seven Dwarfs* (1937). Huebner worked on this film when he was nineteen while attending the institute. After that illustrious start, Huebner's work took off. Not even the removal of his right eye at the age of twenty-nine because of cancer could stop his undeniable talent, and he was able to intellectualize space even though he couldn't see it.

Huebner was an artist in his own right and considered himself a fine artist, who painted landscape portraiture and had long-term ambitions of being an oil painter. But his portraiture was also very distinctive and he was very prolific. Working on a draughting table which tilted, Huebner sketched out storyboards and concept drawings with broad charcoal sticks, and had a larger easel for his paintings. The reason he worked predominantly with charcoal was the style he achieved was much quicker than using pencil drawings. Huebner could take a sheet of vellum and draw a storyboard in half an hour, put it aside and then start another one. Being a very fast illustrator, Huebner could work on two or three movies at a time.

ABOVE Illustrator and storyboard artist Mentor Huebner working at his easel. Courtesy of Jessica Huebner.

"In an illustrative sense, I am directing movies on paper. I've even toyed with the idea of becoming a director," he said. But Huebner didn't relish the thought of directing actors on a set so stayed with illustration, as he had a lot of energy and liked to work.

As art director and production designer David Snyder, who worked with Huebner on *Blade Runner* (1982), remembers, "Mentor was a strictly old school guy; in the times I worked with him, I never saw him with a computer. He wasn't a digital illustrator. He was the kind of guy that came into work every day, and he had a big board, and worked in charcoal. He was a very casual guy, he came in, sat down and drew all day long in charcoal."

Though charcoal was his preferred medium, Huebner occasionally used a black grease pencil on vellum paper. Sometimes he would overlay his drawings and retrace them and build up a storyboard that way, starting out with a sketch and then retracing it. He worked on a drafting table, with larger and smaller easels. It was while working as a storyboard artist at Warner Bros. that he worked on his first Alfred Hitchcock picture, *Strangers on a Train.* Although there are few surviving storyboards for that film, Huebner may have sketched the famous scene of the carousel careening out of control at the end of the film. His daughter Jessica recalls that although he would see Hitchcock in the corridor, he is likely to have had only one meeting with him to discuss storyboards. "The way [Mentor] functioned, he would read the script, and then design the movie, do the shots, and draw what he'd design," says Jessica. "His forte was to design and execute the way sequences should be shot."

The main function of Huebner's storyboards was to set the camera angles and act as a guideline for the cinematographer. "He would make a rough drawing, and then trace it once or twice again, depending how complicated it was," recalls Snyder. "He didn't have to do a lot of rough sketches to get his shapes, they kind of evolved. Even though it was a rough drawing, he projected these things out of his head like a photograph."

After Warner Bros., Huebner moved to MGM where he worked for many years. At the time Cedric Gibbons was the head of the MGM art department,

from 1922 to 1956. He was thought a genius and independent of the administration policy, telling directors what they were going to do and making cinematographers fall in line. Similar to Hitchcock, everyone had to dress according to Gibbons' diktat, and the art department had to wear a white shirt and tie to work. At the end of each working week at MGM, Huebner would take all of his white shirts to the laundry and they would try to wash all the charcoal out.

BELOW Mentor Huebner's sketches show why storyboards are essential for planning and composition. Here Roger Thornhill waits for George Kaplan and another man across the road is waiting for a bus. Robert Boyle measured the distance between the two characters to choreograph the scene.

THE CROPDUSTER

As Hitchcock and Ernest Lehman were writing the script, ideas would be exchanged. Lehman remembers, "One day, Hitch said to me, 'I've always wanted to do a scene in the middle of nowhere—where there's absolutely nothing. You're out in the open and there's nothing all around you. The camera can turn around 360 degrees, and there's nothing there but this one man standing all alone—because the villains, who are out to kill him, have lured him out to this lonely spot.' Then Hitch continued, 'Suddenly, a tornado comes along and—' 'But Hitch,' I interrupted, 'how do the villains create a tornado?' And he had no idea. So I wondered, 'What if a plane comes out of the sky?' And he liked it immediately, and he said, 'Yes, it's a cropduster. We can plant some crops nearby.'" That's how one of the most iconic scenes in Hitchcock's films, and indeed movie history, was conceived.

It was Robert Boyle who suggested the location for the cropduster scene. He remembered a place near where he grew up, as he lived on a ranch in the San Joaquin Valley in the Tulare Lake Basin, where there was an area of flat land. Boyle told Hitchcock that he would go look at it and see if it would work as the location. Hitchcock wanted a place to put Cary Grant in open country where he might run but could never hide.

Then a farmer waits for the bus by standing on the other side of the road. The two men are separated by the road in between, which goes into infinity, and they just stand there. Boyle referred to this as a penultimate moment, namely the moment before something significant actually happens. Though nothing actually happens it's very stressful. Boyle gained much satisfaction from these penultimate moments.

At the prairie stop, Roger Thornhill waits for Kaplan. A cropduster plane appears and machine guns soon open fire. Stripped of all his protection and assets, Thornhill is chased by the cropduster and has to run for his life. He only escapes when the plane crashes into a gasoline truck. For Hitchcock and Boyle, the storyboards were all about conveying feelings—"When a child draws a stick figure, it's about how they feel about their parents, or friends, or whatever and that's what we in movies try and do," says Boyle. "We're trying to get back to that essence of what children instinctively know. We're trying to return to feelings."

Filming for the cropduster sequence began on October 6th 1958 and required sending fifty-five crew members to California Highway 155, East Bakersfield, California. Burks was the director of photography, Leonard South was the camera operator, and Fred Koenekamp was his focus puller on the crane shot high over the corn fields in Bakersfield.

"To begin with, the crew filmed the aerial / crane establishing shots when Roger O. Thornhill is dropped off by a bus," remembers Boyle. "That became a matte shot because in the distance you could see a town. They tied the crane with cable so everything was tight." The scene starts with the high-angle shot to show the vast emptiness. As Hitchcock said, "I decided to do something quite different. I take the loneliest, emptiest spot I can so that there is no place to run for cover, no place to hide, and no place for the enemy to hide." As there were no crops present, Boyle's team planted a fake cornfield in Bakersfield for Thornhill to hide in.

The resulting sequence lasts nine minutes and forty-five seconds and has no music, with only a few words of dialogue. It begins with a wide overhead shot to show the empty nothingness of the plains, with no cover or anywhere to hide. "Going high you show a lot of space around a person, so there's a kind of a loneliness. That's why you can't use long shots indiscriminately, there's always a moment for it. If there's no reason for a long shot, then don't have it," said Hitchcock. He then cuts between Roger Thornhill's point of view and what he sees.

At first the crew shot a swooping plane from a ditch, then later Cary Grant was filmed on the MGM soundstage jumping into a fake ditch, with the plane footage on a process screen behind him. On location, Hitchcock's assistant Peggy Robertson forgot to cover Grant with cropdust when he runs out of the field and Hitchcock had to shoot the whole thing again.

The sparseness of Mentor Huebner's storyboards is exactly what Hitchcock wanted to convey—a man is out in the middle of nowhere, stripped of all his protection and accoutrements. The storyboards also enabled the director and editor to gain a sense of timing.

ABOVE Mentor Huebner's storyboards for the cropdusting sequence showing the first sighting of the cropduster and the ominous words from the farmer, "That's funny. That plane's dustin' crops where there ain't no crops." After the bus leaves, Roger Thornhill is left isolated and exposed on the vast prairie landscape.

During the cropduster attack, Hitchcock kept the shots deliberately long to prepare the audience for the threat of each dive of the plane. The length of the shots was also used to indicate the various distances that Thornhill had to run for cover and to show that there was no cover he could go to. It was necessary for Hitchcock to show the full approach of the plane because it goes by so fast, and if the shots were too tight, then the plane is in and out of the shot so quickly that the audience is not aware of it. The rhythm of the editing helped here, as Hitchcock said, "I don't even know who was in that airplane attacking Cary Grant. I don't care. So long as the audience goes through that emotion."

Do not use aero filter on plates. Use on all other shots

32. P.O.V. Plane going away again.

33. Medium Shot - Thornhill gets out of ditch and runs toward an approaching car. He tries to stop (by Robertson sign) but car goes on.

34. Close Shot - Thornhill looking after departing car. He looks off and sees _____.

35. P.O.V. Plane turning and coming down above road opposite farmer's road

36. Waist shot - Shooting over Thornhill's shoulder - plane is approaching him. Thornhill turns and runs toward camera. Camera tracks back. We now have a picture of Thornhill running with occasional frantic glances over his shoulder as the plane approaches him. The plane gains on Thornhill and dives close to him as he drops to ground out of picture.

37. STUDIO SHOT - Thornhill drops onto side road as the wheels again go above him. Bullets hit the road between Thornhill and camera. (Process plate required) *Herbie NOTE: Camera lens must be on ground level.*

38. Alternate - *see* sketch 39 for alternate shot taken *side* on as Thornhill *rolls* runs under *passing* wheel. (Process plate required)

39. Close Shot - Thornhill *lying* rising in road. He looks off and sees *STUDIO*

40. Long Shot - Corn as *in* Sketch 41

41. Medium Shot - Shooting East Northeast. Thornhill, after looking at corn field, rises and dusts off. *dashes out of screen to the right. In the background the plane* Plane to right in the background is beginning to make a right to left sweep in a forward turn. (Wing over)

42. Closer *shot* up, Waist hight - Starting with stationary camera. Dolly profile shot of Thornhill running with glances over his shoulder left to right. After short run of camera, camera stops and Thornhill runs out of picture.

43. P.O.V. Dolly Shot - Camera moving backwards as though Thornhill, seeing plane beginning to make a turn to come towards Thornhill. (Shot with 50 m.m. and 35 m.m. lenses)

44. Thornhill *dashes* dives from left of *screen* scene full figure and dives *into corn* onto ground (Back *view* field)

45. Flash - Skimming shot of leaves moving as Thornhill dives into the corn and weaves short way through it. The shimmering stops and corn *still*.

46. Medium Shot *STUDIO* - Thornhill lying doggo without any movement in the corn.

47. Objective Shot - Long shot the plane diving towards the corn and turning away.

48. Close Shot Thornhill - A *trace of satisfaction* dolly of set in his face *STUDIO* but still lying doggo.

49. Long Shot - Corn *tipped* tabbed in the corner of the picture. The plane turns and now comes toward camera again. This time it starts to exclude dust. It *sweeps* swerves toward camera excluding dust.

THE CROPDUSTER CONTROVERSY

Much controversy has grown around the cropduster sequence, partly fueled from a memo in the Alfred Hitchcock files in the Academy of Motion Picture Arts and Sciences library. A letter from publicist Rick Ingersoll states, "I'm sending about 13 stills from which I would like Mr. Hitchcock to make the sketches I discussed with him before he left for Europe. As a reminder, they are for *Coronet Magazine*—and theoretically sketches he made before the scenes were filmed. This is for a layout in which his sketches and the resultant scenes would be compared, to show how he maps out every detail of his productions before the scenes are photographed." Ingersoll requested fourteen preliminary drawings for the advertising campaign for *North by Northwest*.

This has led to some suggestion that Mentor Huebner's cropduster storyboards were drawn after the filming was complete for publicity purposes. But Huebner's daughter Jessica denies it: "Absolutely one hundred percent not true, and we have other artwork to prove it." She along with visual effects artist Robert Skotak has been studying and documenting thousands of Huebner's drawings and is very familiar with his work. "I doubt they would have hired Mentor Huebner to do something like that," says Skotak about the publicity drawings. "I've never heard of anything like that being done. Normally they find someone from the publicity department to draw them. Mentor would have gone onto some other project. That's not the kind of thing that he would do. He was way too high-end to do something like that. They are definitely Mentor Huebner's drawings."

Close analysis of the storyboards do show that a few of the drawings look like they were done by someone else, but these shots are supplementary and incidental. There is a shot where Thornhill is looking at his wristwatch, and a drawing where he is by a wheel and where he is looking past the wheel, which look like they were drawn by another sketch artist. Also one of Huebner's defining traits was that he would draw a box around his storyboard sketch, and he would very often tighten up the edges, so that they overlap the borders. His box lines crisscrossed a little bit and overlapped, they are rougher, hand drawings, and his characters and the action overflow outside these borders. Furthermore, the storyboards which show an anomaly are very precise in their line work, and the outside lines are very clean. These boards are drawn with a ruler, with the edges meeting in a very neat drawing style.

What is likely is that Huebner drew the original storyboards, and then when the picture was complete, another artist sketched a couple more boards to complete the sequence; but ninety-five percent of the drawings in the cropduster sequence are Huebner's. The storyboards which are incidental look odd for a Huebner drawing. "There are ones which they want to look exactly like the film. Mentor's boards sometimes look a little different but not very often," says Skotak. "I can't see him varying his style for no purpose. So there are four drawings which were done by someone else."

Production designer Peg McClellan, in her conversations with Boyle, also confirms the storyboards were drawn before filming, remembering Boyle saying, "Hitch knew exactly what he wanted, had it planned shot by shot. We had to find the locations and the elements, as everything had to be timed perfectly." Knowing that Hitchcock always storyboarded his films in advance, the intricate sequence for the cropduster was definitely illustrated before filming began. Boyle also mentioned measuring distances for where the man was to stand, the bus, and the truck, and they planted the rows of corn to match sketches, as well as designing the matte painting for the high-angle shot.

OPPOSITE The precise shot list, which follows the storyboards that Mentor Huebner originally designed. A memo from publicist Rick Ingersoll to Alfred Hitchcock asked for a complete set of storyboards, so after filming, additional boards were drawn up to complement Huebner's designs.

RIGHT Some of the storyboards for the cropduster are likely to have been drawn by another artist for publicity, as the style differs from Mentor Huebner's sketches. Note the very precise borders and graphite pencil neat sketches, which contrast with Huebner's charcoal designs.

RIGHT A combination of location filming and studio work was used for the cropduster dive bombing Roger Thornhill. Mentor Huebner's sketches are characteristically in charcoal where the action is not contained within the borders.

LEFT After the first dive-bomb of the cropduster, Roger Thornhill seeks refuge in the cropfield, which was specially planted with the use of careful storyboarding by Mentor Huebner.

LEFT Roger Thornhill hides in the cropfield which was specially planted. The use of dust to smoke Thornhill out is an excellent example of Hitchcock using his props to the fullest and also to advance the plot.

RIGHT Roger Thornhill running away from the cropduster was a combination of location filming and studio work when he jumps into the ditch. While the rest of the crew flew to Bakersfield, Grant travelled up by car and was paid $5,000 a day for his work.

LEFT Mentor Huebner's drawings for Roger Thornhill trying to flag down the truck.

RIGHT Roger Thornhill looking past the wheel is likely to have been drawn by another artist, judging from the fine rectangular borders and image within the frame, which contrasts with Mentor Huebner's style of coloring outside the lines.

LEFT A fiery explosion ends the cropduster sequence as Thornhill and the truck drivers escape. This storyboard, drawn by Mentor Huebner, illustrates the action and explosion bursting out of the rectangular frame.

THE VANDAMM HOUSE

One of the most famous and admired sets in *North by Northwest* is Phillip Vandamm's mountain retreat above the faces of Mount Rushmore. It's often said that Robert Boyle modeled it after the Modernist architect Frank Lloyd Wright, and it has been compared to Wright's home Fallingwater, which is integrated into the landscape. Wright famously said, "No house should ever be on a hill or anything. It should be of the hill. Belonging to it. Hill and house should live together, each the happier for each other."

The Fallingwater-inspired house with its stone layered façade was integral to the plot, which demanded something for Roger Thornhill to climb up. The house is perched on the top of Mount Rushmore, with a fabulous set design made of the finest stone, wood, and marble, and the use of cantilevers to hold it up. Earthy tones are in keeping with the natural surroundings and a central stone fireplace spans two floors. But as Peg McClellan notes in her conversations with Boyle, just like his childhood memories of the Bakersfield strip providing the location for the cropduster attack, Boyle also took inspiration for Vandamm's house based on a barn near where he grew up.

Boyle was also influenced by his old boss at Paramount; "Hans Dreier once said that a good set is like Swiss Cheese—full of holes; what he meant was that it indicates what goes on outside the space we're in. If there's an opening, the window says there's a world out there. Now many cameramen are inclined to blow out the windows, which means there is nothing outside, which I dislike."

Boyle, with his background in architecture, designed the drawings and sketches for Vandamm's house, including the use of cantilevers, while working in a hotel room in New York. As he stated, "We needed a house where Cary Grant could see everything. It was a house that had no secrets. We could see into the living room, the balcony, and from outside, you could see into [Eva Marie Saint's] bedroom." The drawings depict the exterior of a mid-century modern-style house, hence the extensive use of glass on three sides. Using graphite ink and ink on tracing paper mounted on illustration board, Boyle sketched out the elevation and interior drawings. The Vandamm house was subsequently built on Stage 5 at MGM over two floors.

The Vandamm house was filmed in six days, a total of fourteen pages of script. They also filmed underneath the house when Cary Grant looks for a place to climb. As Eva Marie Saint remembers, "I loved that set. It was stylish and modern. It really felt like a house and had a whole second floor for climbing." With its windows on three sides, there was a real sense of the outdoors.

For the long shots of the house, including the shot where Cary Grant walks up the road to the house, matte paintings were used to convey the grandeur of the sweeping vista in establishing

THIS SPREAD Robert Boyle drawings for the Vandamm house: (below) Elevation and exterior details; (opposite top) Eve inside her bedroom with the windows overlooking the outside; (opposite below) Thornhill holding onto one of the house's stilts. Production design images 20" x 30"

shots, at a time before digital effects. The technique was to paint on glass, which the camera would then film, a technique that was superseded by digital compositing. The matte paintings were produced by Matthew Yuricich, who gained a Fine Arts degree in 1950 at the Miami University in Ohio. One of his first jobs on moving to Los Angeles was working at 20th Century Fox on *The Day the Earth Stood Still* (1951) in Fred Sersen's camera effects department. Then he moved over to MGM and worked on *Forbidden Planet* (1956) and *Ben Hur* (1959). Later works include *Logan's Run* (1976), for which he won a Special Achievement Oscar®, as well as being nominated for the best visual effects Oscar® for *Close Encounters of the Third Kind* (1977).

Other mattes Yuricich designed for *North by Northwest* include the road where Roger Thornhill is arrested for drunk driving, the interior of the United Nations, and the famous high-angle shot of the UN building with only three people in motion near the entrance. His matte paintings were clean and maybe not as realistic as later images, so the house appears a little artificial and quite like a painting.

ABOVE Backdrop design painting depicting an overhead view of the Vandamm house adjacent to a forest and rocky mountain. Paint on canvas

BELOW Matt Yuricich's matte painting for the Frank Lloyd Wright-inspired Vandamm house. Opaque watercolor on illustration board 20" x 37"

MOUNT RUSHMORE STORYBOARDS

The challenge in filming the famous Mount Rushmore chase in *North by Northwest* was to make it believable that two people could climb down the faces of the Presidents. Indeed, the original film title for *North by Northwest* was *The Man on Lincoln's Nose*, based on Hitchcock's and Ernest Lehman's original story.

Robert Boyle traveled to the east coast to begin scouting potential locations for the film. "I prefer to do my own scouting, and I'm sure that most art directors would, because they not only have in mind what they're looking for on the outside but what's on the inside," he said. "An art director is probably more apt to think of it in terms of its particular value to the film, the location value of the film. I don't say that all location managers are like that, but that's been my experience—that is more often true—that they will think of it in terms of logistics."

Boyle and his team embarked on a scouting party to Mount Rushmore, but when a government agency found out what Hitchcock and his film crew were planning to do, namely stage killings on the faces of the national monument, they created an outcry. The Department of Interior wouldn't give permission to film inside the park. Without the necessary permits, the Mount Rushmore monument had to be recreated on the MGM sound stage. This led to Boyle designing one of the most impressive backdrops he had ever created.

"The climb down the faces was all on an MGM soundstage with a rear projection of still shots. The Department of the Interior was very nervous that Hitchcock would make fun of the statue, so they didn't give us permission to photograph there. But they finally agreed to still photographs," recalled Boyle. "It just so happened that Gutzon Borglum, who was the sculptor, had these bosun chairs which would go down each head for cleaning and sculpture. We used the bosun chairs to lower every ten feet on each head, photographing in all directions, so we had complete coverage."

On the top of each of the heads was a huge iron ring, with a cable and a bosun's chair. Boyle volunteered to work with the rusty cable, so he abseiled off the head of Abraham Lincoln, just to see if it all worked, and it was fine until he got down below the eyebrow. The cable, which was very twisted, began to unwind, and it was whirling around, so the team continued to lower Boyle while he was twirling until he reached the bottom. Using this technique, they lowered down each face of the Presidents and photographed in every direction possible every ten feet, and those became the background for the backdrop.

The filming of Mount Rushmore on the sound stage took five days and Boyle had designed a backdrop that was 30 feet high and 150 feet wide. As he remembers, "I think it was one of the finest scenic paintings ever made. Because very often with a scenic painting you put trees. You put a little scrim over it, but we couldn't do that here."

The art direction of *North by Northwest* is truly memorable and is one of the major reasons why it is often regarded as being the definitive Hitchcock film. Robert Boyle's production design, with the help of Mentor Huebner's storyboards and Matt Yuricich's matte paintings, would earn *North by Northwest* an Academy Award® nomination for Best Art Direction in 1959. "[Boyle] was intuitive and also an actor so he felt the script," says production designer Peg McClellan. "He didn't just design a set but designed a string of moments which became the movie and they needed to relate to each other."

Eventually Mentor Huebner got tired of washing his charcoal out of white shirts at MGM, and of course was acquiring some fame of his own as directors were seeing his illustrations and storyboards and would offer him work. He gave notice that he was leaving MGM, left his shirts at the laundry and never looked back. Huebner was a conceptual artist and a designer, and choreographed complicated sequences and set pieces, producing up to four thousand storyboards alone for *The Longest Day* (1962). Some of the famous films he worked on include *Ben Hur*, *The Time Machine* (1960), the initial designs for *Planet of the Apes* (1968), *Fiddler on the Roof*, and *Blade Runner*. One of Huebner's illustrations for *Blade Runner* later sold for $10,000.

ABOVE Storyboards for Mount Rushmore. 8.5" x 11"

BELOW Production storyboards for Mount Rushmore show action of movement of the actors and the camera during the chase sequence.

ABOVE Roger Thornhill and Eve Kendall are chased by Leonard and Valerian during the climax sequence of Mount Rushmore. This sketch was drawn by Mentor Huebner. Brownline on paper 16.75" x 13.75"

ABOVE Thornhill and Eve climb down Mount Rushmore to escape the heavies. This sketch was drawn by Mentor Huebner. Brownline on paper 16.75" x 13.75"

ABOVE Thornhill fighting with Valerian and Leonard while Eve is hanging on for dear life. This sketch was drawn by Mentor Huebner. Brownline on paper 16.75" x 13.75"

ABOVE The storyboard for the climax of the Mount Rushmore sequence shows Eve watching Leonard wrestling with Thornhill. This is different to the finished film, as Leonard falls to his death after being shot by the rangers with the professor. This sketch was drawn by Mentor Huebner. Brownline on paper 16.75" x 13.75"

ABOVE This storyboard depicts Leonard falling to his death after the professor, with a group of rangers atop Mount Rushmore, shoots him. Roger is kneeling and holding onto Eve, who is hanging off the side of the monument. The storyboard was drawn by Mentor Huebner. Brownline on paper 16.75" x 13.75"

ABOVE In the final scene of the film, in both the script and the storyboards, the train leaves the station. "I didn't write the tunnel," says Ernest Lehman—for Hitchcock, who loved phallic symbols, the tunnel was his improvisation. This sketch was drawn by Mentor Huebner. Brownline on paper 16.75" x 13.75"

NORTH BY NORTHWEST • Chapter 5

85

CAST AND CREW

Anthony Perkins
Norman Bates

Janet Leigh
Marion Crane

Vera Miles
Lila Crane

John Gavin
Sam Loomis

Martin Balsam
Detective Milton Arbogast

John McIntire
Sheriff Al Chambers

Simon Oakland
Dr. Fred Richman

Vaughn Taylor
George Lowery

Lurene Tuttle
Mrs. Chambers

Director
Alfred Hitchcock

Screenplay
Joseph Stefano

Story
Robert Bloch

Cinematography
John L. Russell

Film Editing
George Tomasini

Art Direction
Robert Clatworthy & Joseph Hurley

Pictorial Consultant / Titles Design
Saul Bass

Assistant Director
Hilton Green

Script Supervisor
Marshall Schlom (uncredited)

Nude Double
Marli Renfro (uncredited)

Chapter 6

PSYCHO

"The assembly of pieces of film to create fright is the essential part of my job."

— Alfred Hitchcock

PLOT SUMMARY

Secretary Marion Crane steals $40,000 from her employer's client. She drives from Phoenix, Arizona to the town of Fairvale, California to meet her lover Sam. Taking a detour off the main Highway 10 in heavy rain, she stops at the Bates Motel run by Norman, who is under the influence of his unseen domineering mother. Norman and Marion have a chat in his parlor, and afterwards Marion decides to return to Phoenix with the stolen money. However, while taking a shower, she is brutally stabbed to death, seemingly by Norman's mother. A stricken Norman hides the crime by disposing of Marion's body and car in a nearby swamp, along with the money that Marion stole, hidden in a newspaper bundle. Some days later, Detective Milton Arbogast visits Sam at his hardware store, where Marion's sister Lila also comes looking for her. Arbogast traces Marion to the Bates Motel and becomes suspicious of Norman when he interrogates him. When Arbogast enters the Bates house, he is brutally stabbed to death at the top of the stairs by 'Mrs. Bates'. Sam and Lila discover from Sheriff Chambers that Norman's mother has been dead for eight years. They check into the motel as a married couple, and while Sam distracts Norman, Lila goes to investigate the house. In the basement she discovers Mrs. Bates as an embalmed corpse, and is about to be killed by Norman dressed as his mother, before he is overpowered by Sam. At the end, Norman is confined to a mental institution and his dual psychotic personality is realized when his mother takes over.

*P*sycho is arguably Hitchcock's most famous film, and the shower scene is a pioneer in storyboarding that has been emulated and studied by film directors the world over. The shower murder, designed and conceptualized by Saul Bass, is a masterclass in sketching, montage and suggestion. Many audiences assume that the shower murder is very graphic and violent, but in fact very little actual violence is shown, and there is less and less as the film progresses. Through the careful use of storyboarding and editing, Hitchcock worked up his audience into such an emotional state that the expectation of possible violence was all that was needed to excite them. As Hitchcock couldn't show a woman stabbed to death because of the censors in 1960, he filmed his storyboard murder impressionistically, with montage and the cutting together of different bits of film.

Filmed at Revue Studios, which was part of Universal, Hitchcock used a golf cart to drive himself around the lot, and typical working hours were from 7.30am to 5.30pm. Using the storyboards that were drawn up, *Psycho* was filmed by Hitchcock's television crew in only thirty-five days, less than half the normal amount for one of his pictures, with seven days for preproduction. Traditionally the production manager would allow for two and a half pages of script to be filmed in a day, but Hitchcock used his television crew, who worked at a rapid pace. His gamble paid off, because on a budget of $780,000, the movie made $14 million at the box office. "Sometimes you make a small picture like *Psycho* and it turns out to be a bonanza. This is an unexpected thing, perhaps once in a lifetime," said Hitchcock.

For the forty-five seconds that comprise the shower murder, Marshall Schlom, the script supervisor, remembered, "The cameraman would line up the shot, I carried a piece of paper around with me, and Hitchcock would draw a frame line and show the cameraman sketches of what he wanted to do. I learned so much from these pieces of paper, because I listened to him describe what he wanted to do." To storyboard the shower murder, Hitchcock once again turned to Saul Bass, who had been responsible for the superb orchestration of graphics and text for *Vertigo* and *North by Northwest* and who also designed the film's opening credits, where horizontal and vertical bars move across the frame in different directions in a nerve jangling and Modernist pattern.

OPPOSITE Alfred Hitchcock, Saul Bass and Janet Leigh on the set of *Psycho* during filming of the shower murder.

SAUL BASS

*S*aul Bass was born in The Bronx, New York in 1920. After studying art at the Art Students' League in Manhattan and at Brooklyn College, he moved to Hollywood in the 1940s, where he designed print ads for films. He then worked for film director Otto Preminger, creating the opening sequence for *The Man with the Golden Arm* (1955), which made audiences realize the impact that a title sequence could have. Rather than just being empty space at the beginning of a film, Bass's opening titles showed how they could become an integral part to set the mood and tone from the outset. He believed that the audience's involvement with a film should begin with the first frame, which is often the opening titles. "I started in graphics and then I started to move that graphic image in film, somewhere down the line. I felt the need to come to grips with the realistic or live-action image, which seems to me... to be central to the notion of film."

Psycho's titles of horizontal and vertical bars foreshadow the visual composition of the film, which opens with tall skyscrapers and a lunchtime tryst as Sam stands over the horizontal Marion on the bed. Later the image is repeated with the Bates house towering over the horizontal Bates Motel. The fragmented bars of the opening titles are like knife slashes and the fractured letters represent Norman Bates' damaged psyche. Bass said that his main goal for his title sequences was to "try and reach for a simple, visual phrase that tells you what the picture is all about and evokes the essence of the story." In creating the cutting horizontals and verticals, accompanied by Bernard Herrmann's memorable music, Bass achieves just that, and acknowledged, "There seemed to be an opportunity to use titles in a new way, to actually create a climate for the story which was about to unfold."

As the pictorial consultant on *Psycho*, as well as designing the title sequence, Bass was hired to storyboard three main sequences: the shower murder; the killing of Arbogast; and the shocking finale. He was paid $10,000 for his consultancy work beginning in September 1959.

THE SHOWER SCENE

Filming for the famous shower scene took place in December 1959 at Revue Studios, where Hitchcock was making his television series *Alfred Hitchcock Presents*. The shower scene alone was a separate closed set. As Janet Leigh was a famous actress, with a no-nudity clause in her contract, Hitchcock decided to hire a model who had no qualms about being naked on set. Photographer Mario Casilli, who worked for *Playboy* magazine from 1957 for almost forty years, as well as photographing the cover of *TV Guide*, recommended pin-up model Marli Renfro. Renfro was twenty-one years old, and born around LA. She had only featured in two other films, as most of her acting experience was in commercials.

"I was hired for two to three days and worked a total of seven," remembers Renfro. "Basically it was Hitchcock and I and the crew." Renfro met Hitchcock and then Janet Leigh on the sound stage, and had to strip and be approved by Leigh as she was acting as her body double. Renfro wore a little rubber patch made of moleskin on her crotch that Rita Riggs the wardrobe mistress had designed, and little else. "I was a nudist at the time so being without clothes, I was very comfortable," says Renfro. "I wore a gray and white wig which matched Janet Leigh's hairstyle and was in make up for two to three hours at a time." Hitchcock filmed Janet Leigh's hands, shoulders, and head, but all the rest of the footage of the girl in the shower is Renfro.

Hilton Green was the assistant director on *Psycho* and recalled how groundbreaking the movie was in many ways. "Nude in the shower was unheard of for Hollywood. And Mr. Hitchcock wanted a nude photo double for Janet Leigh and so we did that but we locked up the stage so no one could get in." So closed and secretive was the set that all the crew members had to sign a non-disclosure agreement, especially not revealing the shocking ending.

Although Marli Renfro doesn't recall Hitchcock showing her the storyboards from the shower sequence, she does remember that Hitchcock had a big tent on set. "It was a big black cloth tent, like a hunters' tent with a sloping roof on four sides. Inside was a table and chairs, and Hitchcock would sit working on that big table between setups, consulting whatever papers he had."

Janet Leigh, who was filmed for her close-ups in the shower scene, did remember being shown the storyboards after Hitchcock conferred with Saul Bass. "[Hitchcock] said, 'Show me what it's going to look like from this angle, from this and from that, because what I want to do is make a montage. Show me what's it going to look like so I can get in my mind the flash cuts.'"

Hitchcock's professional conduct impressed Renfro. "[Hitchcock] was everything I thought he would be," she remembers. "I would have done the movie for free just to work with him. He put me at ease. I have heard various people in the business not speak kindly of him but that may be personality clashes. He was very professional and totally polite and had a great sense of humor."

Hitchcock's puckish humor during filming of the shower scene helped put everyone at ease. "He took the measuring tape from the end of the lens of the camera and brought it to my left nipple. I thought it was very funny, though he didn't touch me," said Renfro. The blood used in the shower sequence was Hershey syrup mixed with water, which they sprayed on Renfro, and onto the floor. She remembers that one of the stage hands was shaking so hard next to her, as it was probably "the closest he had been to a nude woman before!" Anthony Perkins' double was a tall woman, about the same height and build as the actor, who himself was in New York rehearsing a Broadway play.

More Hitchcockian humor followed after the stabbing, as Renfro recalled: "At the end of the shower scene, I'm sitting down, and I have to reach out my hand to grab the curtain and I have to pull it down [trying] to pull myself up with my right hand, and the focus was on my right hand. And I told [Hitchcock] the ring finger on my right hand was cut off [and re-attached]... and said, 'This is going to show.' And he said, 'How did you do that?' and I showed it to him, and said it was cut off by a lawnmower when I was three, and it [healed] deformed. He said, 'No, that's not what happened—you were picking your nose and sneezed and blew your finger off!'"

Production photographs show Hitchcock, Janet Leigh and Saul Bass during filming of the shower sequence. Bass was very pleased with the results. "Interestingly enough, the storyboard I did for

PSYCHO SHOWER SEQUENCE: EXCERPTS FROM STORYBOARD STUDIES OF COMPONENTS

THIS SPREAD A series of twenty-five composed images from the *Psycho* shower scene designed by Saul Bass. These boards include components that were not included in the final edited scene. It is believed that the drawings on this board were created before filming began and then some elements edited out. Pen and ink on paper mounted on a matte board 22" x 28.25"

(CONTINUED)

Psycho went precisely as I laid it out. And there was no change on that. And frankly I myself at that point didn't really understand the impact that some of these things would have. I thought it was a neat little murder; I thought it was pure, and I liked its purity. I must say that when it appeared in the theater it really scared the hell outta me."

The shower scene in *Psycho* has 78 camera setups and 52 editing cuts, to make 45 seconds of film, and is often described as pure cinema. As Hitchcock later explained, "The knife never touched the body at all. It was just fast cutting from one shot to another. The knife coming at the camera and so forth. Actually the property people at the studio made me a lovely torso with pink rubber and it was all tubed inside with blood. So if you took a knife and stabbed this rubber torso, blood would spurt out. But I never used it. It was all unnecessary because the cutting

ABOVE This storyboard contains a series of twenty four panels showing the sequence as shot for the shower scene designed by Saul Bass. Pen and ink on paper mounted on a matte board 22" x 28.25"

of the knife and the girl's face and the feet and everything was so rapid that there were 78 separate pieces of film in 45 seconds."

The overall impression given to the audience is one of an alarming, devastating murder scene. Hitchcock often said that his main satisfaction was that the film did something to the audience; from a technical viewpoint, it could make an audience scream and create a mass emotion like creating a symphony. This was his definition of pure cinema, and why he described *Psycho* as a filmmaker's film. For Hitchcock, making *Psycho* was also a fun picture. He said, "You couldn't make a picture like *Psycho* without your tongue in your cheek. Because you know people are going to scream."

THE KILLING OF ARBOGAST

Aside from the shower scene, the killing of Arbogast is a bravura set piece which showcases the careful storyboarding and virtuosity Hitchcock and Bass used to whip the audience into a frenzy. One of the ways that Hitchcock cleverly created suspense was to give the audience more knowledge than the characters, so that we very often feel anxious for them. So when Arbogast enters the Bates house to investigate we know, from the door being ajar at the top of the stairs, that the murderous Mrs. Bates is waiting for him, and we are squeamish yet willing accomplices as we anticipate more bloodshed. However, Bass and Hitchcock initially had different ideas on how to storyboard the second murder.

"The storyboard for Arbogast was that as Arbogast walks up the stairs, I called for cuts, of his hand going up the rail," recalled Bass. "I called for cuts of his feet, just his feet moving up the stairs. And I also want to set up the balustrade, and that's why I wanted the hand cuts, because I wanted the vertical balustrades that were on the hand rail. Because later what I had in mind, that when he gets hit and killed, that when he falls down the stairs, I wanted his hand to go through all the vertical spindles and go through and cut right down the thing. Now when I laid that out, I brought it to Hitch who then said, 'No. Wrong!'"

Hitchcock confirmed, "When I saw them, I said, 'You can't use any of them.'" The sequence told in that way would indicate that the detective was a menace because of the way it was edited. The fast cutting would create suspense. But Hitchcock's thinking was that this is an innocent man; therefore the shot too should be innocent. He didn't feel the need to work the audience up into a frenzy. He had already done that. The mere fact that Arbogast is going up the stairs is enough. So he decided to keep the storyboarding simple with no complications and use one continuous rigged shot of him going up the stairs.

ABOVE Production sketch by Hitchcock's art department of the Bates house interior, showing the Gothic elements and setting the scene for Arbogast's murder and Lila's exploration of the house. Creator not credited.

ABOVE Production sketch by Hitchcock's art department of Arbogast on the stairs. A gimbal was mounted to create the effect of following the detective up the stairs in a continual shot until it is overhead. Hitchcock felt with the high-angle shot the audience wouldn't feel cheated not seeing the attacker's face, compared to if the camera was behind the attacker on the landing. Creator not credited.

Script supervisor Marshall Schlom remembered showing the sequence, which he and Green had filmed one day when Hitchcock had the flu, to Hitchcock in the projection room with George Tomasini. "When it came to the Arbogast sequence, we showed him what we did, and the lights were dim. After the showing to him, we turned off the stop and go, he went up to the screen, turned around and put his hands behind him and said, 'Fellows, we've made a big mistake.'" Hitchcock asked to take out all the hand shots on the rails. The shot just needed a simple statement, showing a man going up the stairs in a very simple way, with an air of caution, otherwise the storyboarding of multiple cuts of the man's journey up the stairs would ruin the cuts that Hitchcock needed at the time of his death. "So we devised a way, camera floating and the hand came in right in front of that frame, and we cut to Arbogast going [up the stairs] like this, so that's what we have in the film," Schlom finished.

The Arbogast murder was shot in a day, and to prepare for that, Green recalls that a very complicated rigging from the ceiling of the stage was required, as the rig that held the camera needed to pull up and then do a hundred and eighty-degree pan when it reached the top. The camera was mounted on a gimbal so that it floated. At the time, Hollywood didn't have the equipment they do today, so the grip crew would rehearse the shot for fifteen to twenty minutes each day in preparation.

Hitchcock's favorite term for an extreme close-up was a "big head," which he used when Arbogast is stabbed in the eye. As Hitchcock said, "One of the biggest effects in *Psycho* was where the detective enters the house and goes up the stairs. The shots were storyboarded to make sure there was enough contrast of sizes within the cuts… Here is the shot of the detective, a simple shot of going up the stairs, he reaches the top stairs, the next cut is the camera as high as it can go; it was on the ceiling. You see the figure run out, raised knife, it comes down, *bang!* The biggest head you can put on the screen. But the big head has no impact unless the previous shot has been so far away."

When storyboarding Arbogast's murder, Hitchcock was conscious that the audience shouldn't be aware of the size of the image change. "When the detective got to the top of the stairs, and I took the

camera to the ceiling, for the figure to run out with the raised knife, and when it came down, *bang*, into a big head—shock to the character and shock to the audience. But the shock comes only in relation to the sudden change in size."

When shooting 'Mrs. Bates' coming out of the bedroom to stab Arbogast, and later when she is being carried downstairs by Norman, Hitchcock chose to do so from a high angle, because he didn't want it to be apparent that he was deliberately concealing Mother's face. The latter scene was originally written to cut to a high angle when Norman goes up the stairs to fetch his mother, but Hitchcock rewrote it so that the camera would stay at ground level shooting up. It's only when Norman goes up to his mother's room and has an off-screen argument with her that the camera starts moving. During all this, as Hitchcock said, "The camera has been creeping up the stairs. It does not stop at the top, however, but continues on to the same high angle as in scene #57 when Arbogast was stabbed." The effect of storyboarding this is like the orchestral symphony which Hitchcock often spoke about.

Hitchcock's storyboarding paid off and shocked audiences around the world. "We had a cast and crew running of the film," recalls Schlom. "When this shot came and the knife came in, everyone in the audience in front of us came off their seats this far… In the dark, except for the flickering of the projection, [Hitchcock] bent forward to look to me, and he smiled. That was his way of saying, 'I told you this was going to happen.'"

THIS IMAGE Production sketch by Hitchcock's art department for the scene where Norman Bates sinks Marion's car in the swamp, along with her body and the stolen money wrapped in a newspaper. Creator not credited.

CAST AND CREW

Rod Taylor
Mitch Brenner

Jessica Tandy
Lydia Brenner

Suzanne Pleshette
Annie Hayworth

Tippi Hedren
Melanie Daniels

Veronica Cartwright
Cathy Brenner

Ethel Griffies
Mrs. Bundy

Charles McGraw
Sebastian Sholes

Ruth McDevitt
Mrs. MacGruder

Lonny Chapman
Deke Carter

Director
Alfred Hitchcock

Screenplay
Evan Hunter

Story
Daphne Du Maurier

Cinematography
Robert Burks

Film Editing
George Tomasini

Production Design
Robert Boyle

Assistant Director
James H. Brown

Set Decoration
George Milo

Pictorial Designs
Albert Whitlock

Art Department
Harold Michelson (Storyboard Artist; uncredited), Will Ferrell (Scenic Artist; uncredited)

Chapter 7

The Birds

"It was a meeting of equals: the director who knew exactly what he wanted, and the art director who knew how to get it done."

— Robert Boyle, production designer

PLOT SUMMARY

Melanie Daniels meets Mitch Brenner in a San Francisco pet shop and becomes smitten by him. She follows Mitch to his home town of Bodega Bay sixty miles up the coast and delivers a pair of love birds for his sister Cathy's birthday. When Melanie crosses the bay in a hired boat, she's hit by a lone seagull, which draws blood. Mitch takes her to the Tides Inn to tend to her wound, where Melanie meets Mitch's mother Lydia. Despite Lydia's obvious suspicion and hostility towards Melanie, Mitch invites her for dinner at the Brenner house that evening. Melanie stays the night with Annie Hayworth, the local schoolteacher, and an ex-girlfriend of Mitch. The bird attacks inexplicably escalate; first at Cathy's birthday party, and then when a flock of sparrows invade the Brenner house through the chimney. The next morning Lydia discovers the dead body of her neighbor Dan Fawcett with his eyes pecked out, and Melanie tries to calm her by suggesting to pick up Cathy from the school. While she waits for Cathy's class to finish, crows silently gather on the jungle gym and attack the school children when they attempt to run down the hill. The birds attack the town after the people take refuge in the Tides restaurant. Afterwards Mitch and Melanie discover that Annie has been killed when they go to pick up Cathy. Mitch boards up the Brenner house and the family and Melanie are trapped inside when the birds attack. When Melanie investigates a noise in the attic, she is brutally assaulted by more birds and is only just rescued in time. The family attempt to flee in Melanie's convertible as the birds watch them go.

ALFRED HITCHCOCK'S　　　　'THE BIRDS'　　　　PROD. DES. ROBERT BOYLE
MATTE BY ALBERT WHITLOCK

In 1961, Hitchcock was looking to top the enormous success of *Psycho*, which had been a hit with audiences and critics alike. He once again turned to the work of English novelist Daphne du Maurier, as he had adapted *Rebecca* over twenty years earlier and was familiar with the author's work. Du Maurier's short story 'The Birds' was set in Cornwall and followed a farmer named Nat Hocken and the inexplicable attacks by flocks of birds. Hitchcock was intrigued by the story, especially the element of chaos erupting and the theme of nature suddenly turning against man, especially at a time when the Cuban Missile Crisis was very much in the news.

During this time, Hitchcock and his staff were in the process of moving from Paramount to Universal Studios. Their new bungalow was accessible to the stages, and a hallway led to the production departments, including art, editing, and Hitchcock's own projection room. "And it was the only one of its kind on Universal's lot and it was just marvelous to work under those conditions in respect that you had everything right in the center of the studio," remembers production designer Robert Boyle.

There were a hundred people on staff in Universal's art department, with eleven set designers, and that was the last time there was an art department fully on staff on payroll every week. That was the way Universal bosses Lew Wasserman and Sid Sheinberg wanted it—a fully operational twenty-four/seven art department.

Hitchcock's immediate challenge was how to show the birds attacking in the age before CGI. When writing the script, he told his screenwriter Evan Hunter not to be concerned about the technical details as this would be overseen by his technical department. A film such as *The Birds* required hundreds of special effects, so many storyboards were made to combine the live action with matte paintings and real birds with the use of blue screen and rear projection, all of which had to be carefully storyboarded.

ABOVE A bird's-eye view of Bodega Bay, with two fires visible in the town. This illustration was created to show how matte shots and actual footage would be combined to create an overhead shot of birds over Bodega Bay. The final matte was painted by Albert Whitlock. Opaque watercolor over illustration board 15" x 23"

ROBERT BOYLE

Heading the production design was Robert Boyle, who was the first crew member to be assigned in the summer of 1961. Having worked with him on *North by Northwest* and *Saboteur*, Hitchcock knew that Boyle was the top production designer he needed to create the mood and deal with the complicated bird attacks.

For Boyle, birds had already made an indelible mark on him. "I guess I was about five years old. We lived on a ranch in the San Joaquim valley. My father thought I should go and see this movie, *Rescued from an Eagle's Nest* [1908]—this eagle carries off this baby to its nest. I was terrified and this affected me about films for quite a long time." Boyle spoke to Hitchcock about how birds loom large in human history and mythology, both in the conscious and unconscious, as Freud had mentioned. It seemed an appropriate subject for Hitchcock, who often worked in the subconscious in his films such as *Spellbound* and *Vertigo*. Birds had featured in his last film *Psycho*, and Norman Bates was very much like a bird of prey, surrounded by his taxidermy.

Hitchcock asked Boyle to read du Maurier's short novella and see what they could do with it. When he read it he was impressed by the mood of the piece. "And something that came to mind was the painting by Norwegian artist Edvard Munch, *The Scream*, which seemed to be a scream about what was happening in the world. And I put down on paper some thoughts I had, and the kind of situation it called for," remembered Boyle.

The Scream was the name given to four versions of a composition depicting a woman standing on a bridge holding her head and letting out a terrified scream. "And I was bowled over by its

ABOVE Robert Boyle created a series of mood boards when starting production.

Alfred Hitchcock Storyboards

102

THIS SPREAD Boyle's preliminary sketches, which he saw as mood pieces, having read Daphne du Maurier's short story. The parallels with Edvard Munch's *The Scream* are obvious in the setting of the figures on a wooden pier. The mood sketches he painted show a man and child on a footbridge being attacked by hovering seagulls and crows hiding in the long reeds. Watercolor, charcoal and graphite on illustration board

strength. I just made some little sketches and I must admit that what I saw was Munch's *The Scream*, which I thought was to be a symbol of the terror that birds can strike in the hearts of many people," remembered Boyle. It was this terror and despairing mood that Boyle wanted to replicate for the production design of *The Birds*; all muted colors, gray and cloudy skies. "For me, the birds represent the rebellion against man's disregard for nature in general, and man forgets he needs nature's help," said Boyle.

Boyle spent the rest of the night working on the preliminary sketches and took those to Hitchcock, who thought they were reasonable. He again met with the director in mid October 1961, to go over the script and start breaking it down into a series of shots, sketches, and layouts. Boyle scouted a number of places in Northern California, and settled on Bodega Bay. What he found was that Bodega Bay and its surroundings were often too sunny and picturesque to suit the inspiration, so they had to subdue the color of many of the scenes to get the required look.

After the sketches were made, Hitchcock and Boyle's thoughts turned to the technical aspects of making the film and how they could convincingly combine the bird attacks with the actors. "I decided to do a little survey, and I went all around town, talked to people in many studios," says Boyle. "Everything pointed to the fact that in those days we knew we were going to have mattes of some kind. Some of it would be superimposed, but many places we would have to have traveling mattes." All of which had to be storyboarded.

HAROLD MICHELSON

The complicated setups, and the combination of many locations with composite shots, needed careful drawing by an expert illustrator. Boyle turned to Harold Michelson whom he had worked with before, and who had been working at Paramount on films such as *The Ten Commandments* (1956). Michelson himself had worked for Hitchcock at Paramount, learning the art of draughtmanship; he had sketched storyboards for *Rear Window* and *The Man Who Knew Too Much* (1956), but his boards were sent up to the director, and he never had any interaction with Hitchcock himself.

"One of the best storyboard artists was Harold," affirmed Boyle. "I had known Harold for some time, and I knew that getting my crew together to make *The Birds*, we had to have people like Harold. For one thing, Harold could draw very well but it was above and beyond that."

After leaving the United States army, Michelson enrolled in the Arts Students League in New York to learn how to be an illustrator. He went around the advertising agencies with his samples but wasn't treated very gently. "I soon realized that wasn't the place for me," Michelson observed, so he moved to California and got a job as a salesman. He took his illustrations around the various studios and then received an unexpected call from a man who mistook someone else's work for Michelson's. "'Are you the guy who did those drawings?' I said, 'Yes,' and they said, 'Can you come to work on Monday?' I said, 'Yes.' Whoever did those drawings may now be selling insurance!"

Michelson was given the script and would discuss the scene with Boyle. He would also give the storyboards as much detail as possible, feeling that the script had to be enhanced by a lot of images. He drew little compositions and many of the storyboarding had no dialogue, for example the scene with the leaked gasoline: "It was obvious to me there was no talking and it worked." Michelson also liked to give details like shadows to his storyboarded figures, rather than simplistic stick men.

As Boyle affirmed, "Harold has an extraordinary sense of film. He only draws what the camera sees. He reproduces in storyboards what the lens sees exactly. From his storyboard you could tell what lens you should use, what the angle of the camera was. Harold was a master of his technique and his storyboards always represented a shot that you could get with the camera."

For Michelson, drawing storyboards was most satisfying, as he was in a room by himself and sometimes had the whole studio to himself just to draw. He saw it as directing on sketches, which he found very rewarding. "I did a tremendous body of work, every time the birds were there, you couldn't shoot the birds, they had to be printed afterwards, the layers. I did an awful lot of layers. [Hitchcock] was cutting the movie in his mind."

Yet despite Michelson's enthusiasm for the script and brimming with ideas, Hitchcock didn't always agree. Just like his deviation from Bass's storyboards for Arbogast's murder in *Psycho*, he had other ideas for *The Birds*. Michelson went to see Hitchcock, who said, "'This is really very good, but I can't use it here.' That's when I knew that we were doing a symphony with the low notes and the high notes. The director has to put it all together and know where [elements go]."

Usually the storyboard artist stays behind at the studio when the rest of the production crew go on location. This was the case for *The Birds*, when Hitchcock took his film crew to film in Bodega Bay at the end of February 1962. "So in many cases, I was on my own interpreting the script." But circumstances changed when, a few months into production, Michelson was invited on location in Bodega Bay to carry out further work on the film's complicated bird attacks.

Hitchcock liked Michelson's work enough to ask him to join the location crew. Michelson, due to the way he thought, was someone Hitchcock related to. As many of the important storyboards included birds, the feelings that they generated had to be articulated, and the only way to express it was through drawing the storyboards. "So evidently, what I was doing was right," Michelson surmised. "And Hitchcock's method of shooting, moving in on a subject slowly, or an objective or subjective way of shooting, which I hadn't heard before—I, of course, went along with it, and learned an awful lot about how to make a movie." If there were any variations to the storyboards, they were mostly variations on the interiors, but usually Michelson didn't make continuity drawings for a two-person scene in the living room.

Despite the extraordinary premise of birds attacking humans, Hitchcock sought documentary realism for his film. To that end, every man, woman, and child in Bodega Bay was photographed to see what they wore. Boyle also researched the houses in which the characters lived, paying special attention to the set décor, and creating realistic interiors, especially for the Brenner farmhouse where Mitch lives with his mother Lydia and sister Cathy.

Boyle laid out the set requirements for furnishing the interior in a memo in January 1962 just a couple of months before filming. "The first consideration should be that the Brenners are reasonably educated and literate people…The general atmosphere of taste and character would be, it would seem, to combine that of the mother and her son." Hitchcock himself described the Brenners as "Pleasant people, and, as I say, literate, educated. I imagine if they hadn't had the money, they would have been kind of bohemians almost, you know." A character study written for Lydia surmised she had sold the apartment in San Francisco to live permanently on the farm in Bodega Bay, taking some key furniture items with her and giving the rest to Mitch for his apartment in the city.

BELOW Michelson's opaque watercolor on an illustration board shows Mitch and Lydia washing the dishes after Mitch invites Melanie for dinner. The scene shows the geography of the house and introduces the china motif, which is later broken during the bird attacks.

BOTTOM This opaque watercolor by illustrator Michelson shows the layout of the Brenner living room, which would become instrumental in the bird attacks; first by the sparrows which come down the chimney and then during the climactic bird attack on the house where the humans are caged inside.

Production illustrations were designed by Boyle for the Brenner house in full color. Set designs were made for the living room, kitchen, and upstairs guest bedroom. It was important to establish the geography of the house, as the architectural space would become important during the bird attacks. The masculine furniture emphasized Lydia's ties to her dead husband, his portrait presiding ominously over the fireplace, and her clinging to the past.

Lydia and Mitch washing dishes after their meal with Melanie evokes a married couple, and establishes the motif of the china, and her Oedipal ties to her son. Her fragile nature and world falling apart is wonderfully conveyed by the broken china after the bird attack. Lydia's nerves are shattered when the sparrows invade the living room through the chimney while Melanie and the Brenners are having supper after the birthday party, and then in the climactic bird attack on the house when the birds tear at the front doorway and windows and manage to penetrate the house through a hole in the attic roof.

After extensive scouting, Boyle found a suitable house for the Brenners. Rose Gaffney was a local who owned the farmhouse in Bodega Bay on which the Brenner house was based and where the exteriors were filmed. Boyle used her house as a model, as well as that of other wealthy residents in the area, including a house owned by the Chancellor family.

ABOVE Michelson's production sketch for the Brenner's guest bedroom where Melanie stays the night after the sparrow attack. The sloping roof and attic windows suggest where the birds can penetrate during the climactic attack on the house. Opaque watercolor on illustration board

BELOW Another production sketch by Michelson shows the sparrow attack as Mitch attempts to block the fireplace with a table. Leonard South the camera operator recalls that birds were all over the place when he was filming, and going home for dinner that night, his wife cooked chicken which he couldn't eat. Opaque watercolor on illustration board

SUSPENSE BUILDING IN THE SCHOOL HOUSE

Michelson sketched many scenes for *The Birds*, including the school children running down the street being chased by crows. Hitchcock's trademark suspense and use of the camera is indelibly stamped throughout the film. He often outlined the difference between mystery and suspense. "There is no terror in the bang, only in the anticipation of it," Hitchcock famously said. All suspense comes out of giving the audience information. If you tell the audience that there's a bomb in the room and that it's going to go off in five minutes—that's suspense. The storyboarding of *The Birds* provides excellent examples of this type of suspense building, especially in the celebrated jungle gym sequence. When Melanie sits in front of the jungle gym outside Bodega Bay school waiting for the children to finish their song, she starts to smoke a cigarette. Little does she know that, one by one, crows gather on the bars of the jungle gym behind her. When she notices a lone crow flying in the sky, her eye follows the crow's flight down to the jungle gym to discover the crows en masse.

Although Michelson drew these storyboards, both he and Boyle affirmed that the execution was Hitchcock's idea. Boyle remembered, "He said that Melanie will come out of the school, we hear the children singing in the background, and she's very relaxed, no problem, she goes down and sits by a fence, we see a bird come in. We're in a loose [full] shot of Melanie, she gets a cigarette and starts to smoke a cigarette, very relaxed, we see another bird come in. Then we're in a little closer, another bird, and we do this several times. When we finally get to a choker shot, we'll hold it until the audience can't stand it anymore. Once you've heard that you know how to draw!"

Michelson would then draw out the storyboard: "When [Melanie's] sitting in front of the jungle gym, the shot back and forth, and moving closer and closer, I did that but it wasn't my idea. We got ideas from Hitch and tried to interpret them. He's a very visual guy, but he was able to communicate what he wanted." The storyboards were then passed onto the various departments, including Robert Burks the cinematographer, the special effects team, and wardrobe and make up.

"As a subjective director, the scene also dictated how it was going to be subjective," described Boyle. "It didn't necessarily mean a close-up and what the close-up sees. If the scene is working, even a long shot can be subjective because it's expressing what the character is feeling. And that's what he was interested in, putting you the audience in the character. It might be a standard viewpoint shot. Sometimes a great long shot, a long vista could be revealing what a character felt. He was mostly interested in feelings." Boyle's story shows how effective Hitchcock was with articulating his visuals to his production crew and how he was mostly interested in generating feelings from the audience.

The storyboards were essential to integrate the location filming of the children running downhill, which assistant director James Brown filmed on Taylor Street in Bodega Bay. Twenty children, a mix of Hollywood kids and local children, ran down the long hill towards the bay. As Bodega local Janet Ames remembered, "I was one of the children at the birthday party and at the school house. The casting director came to the school and said, 'Do you want to be in the movie?' We were filming for about ten days. They brought in four or five Hollywood children."

Suzanne Pleshette, who played Annie the plucky school teacher, remembered, "In the scene when we are running down the hill when the children are being attacked, I didn't have the birds," as the crows would be double printed on afterwards. "I had to swoop up one of the children and run; for me it was more of a case of exercising than worrying about being killed."

The close-ups of Melanie and the children would later be filmed in the studio on a treadmill, wearing the same clothes from the location. Even the birds had their own costumes as wardrobe mistress Helen Colvig recalls: "We designed hoods for the birds made of black silk stocking and the sewing room was involved. They were hoods to blind the birds and they'd line them up on the wires. And they'd sit there because they couldn't fly."

437 - crows fly away from playgrnd equip at sound of children running.

BODEGA SCHOOL YARD.

matte

438 - crows over school.

438A crows head for children.

matte

Alfred Hitchcock Storyboards

108

THIS SPREAD Storyboards for the attack on the school house in 24 panels broken into 3 scenes. Melanie sits on a swing, whereas in the final cut, she is sitting on a bench smoking a cigarette in front of the jungle gym. Boyle recalled that Hitchcock wanted a tight close-up of Melanie's face as the crows gather silently behind her. The sequence of the attack on the school house was carefully storyboarded to integrate the filming location with the studio work, which involved the children running on a treadmill, with traveling mattes and the use of both trained and mechanical birds.

The Birds • Chapter 7

109

MATTE PAINTINGS

To achieve Boyle's vision of the gloomy look and gray skies inspired by the Munch painting, the production turned to Albert Whitlock, whom Hitchcock had known since his days at Gaumont Studios in London filming *The 39 Steps*. When Whitlock moved to California, he started working at Disney alongside fellow matte artist Peter Ellenshaw, where they mastered the matte process. Whitlock became head of the Universal matte department in 1961 and was known for the original negative matte shot, which combined oil paintings and live action and which was incredibly photorealistic. Whitlock favored the latent image matte shot, where black mattes are applied to areas of glass, which will be later painted. The matte is designed to prevent exposure, and cardboard pieces are cut to the exact shape of the area to be protected, before being mounted on a matte box in front of the camera lens. Whitlock perfected the technique of juxtaposing live action with painted elements on the same original film negative.

The live-action footage for the mattes would be shot by the cameraman and engineer, and storyboards would be provided for them. "They'd take the camera, go to the live action and take a black card and cut out a hold-out matte," explains storyboard illustrator Joseph Musso. "So they would record where the footage was in the camera that had been shot. And then they would take that footage from the VistaVision camera, and then go back to Whitlock and they would project it and he would know where the painting would have to go on glass."

As Whitlock remembered, Hitchcock himself had a clear vision in his mind about the look of the film: "Hitch will say, 'I don't want scenics, Al. I want this to be a story scene… but I want to make the point of a lowering mood, so let's have some of your clouds there." Whitlock's task was to paint in those bland skies. He had his own painting studio close to Hitchcock's bungalow and the art department, and a painting could take a week and a half for him to complete.

To begin with Whitlock painted fifty oil paintings to convey mood, which Hitchcock was interested in and said, "Let me not lose the mood that you have in these paintings." Whitlock's personal inspirations for the Bodega Bay skies were John Constable and William Turner, 18th century English landscape painters. Whitlock particularly admired Constable's *The Hay Wain* and would often quote the painter, who said, "The sky is an organ of sentiment."

The multiple locations that Boyle had found on the scout, some in Bodega, others in Bodega Bay or Bodega Head, needed to be tied together to keep the look of the picture ominous and moody. Whitlock's mattes aptly provided the mood and background to blend in live action with the special effects. He painted his mattes on brown butcher paper, first sprayed with shellac so that the oils he used wouldn't be absorbed into the paper. Matte paintings were three feet square and as Whitlock's background was as a scenic painter, he could produce mattes using only a minimum of paint. He also used a limited palette of Winsor & Newton oils made up of titanium white, alizarin crimson, ultramarine blue, cadmium yellow, raw umber, burnt sienna, yellow ocher, Winsor green and mars black. For mattes, Whitlock preferred sign painter's shiny black enamel as it only reflected specular light and not ambient light. Using this color range, Whitlock mixed any color he needed, rarely using black except to darken skies. He painted with a one-inch and a two-inch short bulletin stroke brush, favoring the Grumbacher brand.

Whitlock created over a dozen matte paintings for *The Birds*, which took nearly a year to complete. "If it was an important shot, such as this shot looking down on the town of the birds coming down, he'd say, 'You know why I want this shot, Al?' And then he'd give you an explanation of why he wanted it," Whitlock said in an interview. Hitchcock never made a shot just for a beautiful shot; everything had to advance the story. "He hated the term 'establishing shot.' It had to be part of the story. I don't remember doing anything for him that wasn't absolutely necessary and vital to telling the story."

Whitlock painted the famous matte shot of the high angle of the town of Bodega Bay at the director's request. Hitchcock wanted a high-angle

THIS PAGE Nine panels of storyboards with bird trainer Berwick's trained crows and the attack on the townspeople by illustrator Michelson. Pen and ink on tracing paper mounted on illustration board

The Birds • Chapter 7

447 Michele & Cathy on foreground road – Background children & bikes on sodium background plate.

448A

448 Melanie foregd – Birds – running children – Background

455

ABOVE & OPPOSITE The crows attack the school children as they run down the hill alongside Melanie and Annie. The sequence is a combination of location filming and process work. For Melanie and the children running, traveling mattes and sodium vapor background plates were used. The storyboard is broken into three vertical sections composed of three images each, the ninth one being blank (not shown). Pen and ink on tracing paper mounted on illustration board

shot of the birds attacking. The shots before the aerial are mostly in close-up, of the characters edited at a very fast pace, such as the man lighting a cigarette leading to the gas explosion, then the quick cuts of Melanie reacting in horror, and finally ending with a dispassionate aerial shot. "I did that high shot for three reasons," Hitchcock said. "The first was intended to show the beginning of the gulls' descent on the town. The second was to show the exact topography of Bodega Bay, with the town, the sea, the coast, and the gas station on fire, in one single image. The third reason is that I didn't want to waste a lot of footage on showing the elaborate operation of the firemen extinguishing the fire. You can do a lot of things very quickly by getting away from something." The high shot was an explanatory shot, which Hitchcock called "God's point of view" and he wanted a shot that was very violent in contrast to the other shots.

Hitchcock really put together an A-team for a film as complex as *The Birds*, with its 371 special effect shots, and through the production design of Robert Boyle, Albert Whitlock's matte paintings, animation by Ub Iwerks, Harold Michelson's storyboards, and the use of birds trained by Ray Berwick, the film was nominated for an Academy Award® in Best Effects. Though it lost to *Cleopatra* (1963), which Hitchcock dismissed as "quantities of people and scenery."

The Birds • Chapter 7

113

CAST AND CREW

Tippi Hedren
Marnie Edgar

Sean Connery
Mark Rutland

Diane Baker
Lil Mainwaring

Louise Latham
Bernice Edgar

Martin Gabel
Sidney Strutt

Alan Napier
Mr. Rutland

Bob Sweeney
Cousin Bob

Mariette Hartley
Susan Clabon

Bruce Dern
Sailor

Director
Alfred Hitchcock

Screenplay
Jay Presson Allen

Story
Winston Graham

Cinematography
Robert Burks

Film Editing
George Tomasini

Production Design
Robert Boyle

Assistant Director
James H. Brown

Unit Manager
Hilton Green

Set Decoration
George Milo

Pictorial Designs
Albert Whitlock

Art Department
Harold Michelson
(Storyboard Artist; uncredited)

Chapter 8
MARNIE

"Hitchcock loved matte shots and he loved to make the audience wonder how did they get that shot."

— Hilton Green, unit manager

PLOT SUMMARY

Marnie is a thief, and changes her identity and appearance after robbing each employer. Her only attachments are her mother, who lives in Baltimore, and her beloved horse Forio whom she rides after each robbery. She takes a job at Rutland and Co. publishers in Philadelphia, where the owner Mark Rutland recognizes Marnie from her previous employer Strutt, whom she just robbed. He hires Marnie out of curiosity and asks her out on a series of dates after comforting her in his office during a thunderstorm. When Mark takes Marnie to visit his father, his sister in law Lil is jealous and suspicious of Marnie. After robbing the Rutland safe, Marnie escapes to ride Forio but is tracked down by Mark. He forces her into marriage and the two embark on their honeymoon cruise where, after sex, Marnie tries to drown herself in the ship's swimming pool. Mark, realizing the seriousness of Marnie's problems, returns home, brings her horse Forio, and also tries to uncover why Marnie is fearful of thunderstorms and the color red. After Lil invites Strutt to a party in honor of Marnie, Strutt recognizes her and threatens to press charges. Mark tries to convince Strutt not to, as the money has been returned. While Marnie rides in a fox hunt, she panics at the sight of the huntsman's red jacket and sends Forio into a wild gallop with Lil in pursuit. When Forio breaks his leg attempting to jump a wall, Marnie is forced to shoot him. She tries to rob the Rutland safe once more but is caught by Mark, who takes her to Baltimore to confront her mother. During a flashback, Marnie recalls that as a child she accidentally killed a sailor with an iron poker and that her mother was a prostitute. Her compulsive thieving, her fear of sex and the color red are linked back to this traumatic childhood moment.

Hitchcock's next film, *Marnie*, was a very different movie to its predecessors. After the shock of *Psycho* and *The Birds*, Hitchcock opted for a change of pace and was more interested in a character study and portraying the psychology of a compulsive thief. "After two shockers, I decided to return to psychological drama. I compare *Marnie* to *Spellbound*, a bizarre situation, a psychological roller coaster ride," said Hitchcock. When being interviewed by Peter Bogdanovich during the release of his next film, *Torn Curtain*, he agreed that *Marnie* had the most depth of his three most recent pictures.

As *Marnie* is a psychological thriller and character study, Hitchcock was very interested in conveying to the audience the subjective state of the character. In doing so, he had to use all his film grammar so that the audience would identify with a character who is a compulsive thief. Unlike *The Birds* there were no complex action sequences that involved layers of special effects. Yet most of the film was still carefully storyboarded to guide the cameraman, art department, wardrobe, props, and set dresser.

This depth of preproduction is carried over in the storyboards and what Robert Boyle described as Hitchcock's interest in feelings. The use of subjective viewpoint and careful planning culminates in *Marnie*, through the expression of repressed memories and the subconscious. There were a number of complicated set pieces in *Marnie* which needed careful storyboarding to blend the location filming with the studio work. This included the racetrack sequence where Mark takes Marnie on a visit, and also the climactic fox hunt which leads to Marnie shooting her beloved horse Forio. Hitchcock often favored studio work so he could control the lighting, and it was also expensive to take actors and crew on location. So the storyboards

BELOW Diane Baker and an extra ride horses on treadmills in front of the rear projection which was carefully storyboarded in the hunt sequence. The rear projection was scheduled for the end of filming as it needed careful organization with the use of process plates and horses trained by Jack Carry.

① L.S. MATTE - GATHERING OF HUNT. SHOT

MED. S. MARK - CAMERA DOLLIES IN TO → SHOT

② C.U. MARK - WATCHING. SHOT

MED. S. MARNIE - TURNS - FOLLOWS HUNT. PLATE X 420-1(A) PROCESS

had to reflect Marnie being a picture that was filmed mostly in the studio, but with some degree of process work, back plates, and location shooting.

Once again Hitchcock enlisted his A-team from *The Birds*; production designer Robert Boyle, assistant director James Brown, pictorial consultant and matte artist Albert Whitlock, and storyboard artist Harold Michelson. Story outline conferences with Boyle began in February 1963, and he set about the production design for *Marnie*. Michelson began storyboarding in mid October 1963, a month prior to the film starting shooting. The main function of his storyboards was to communicate to other members of the production team so that everyone was on the same page when it came to filming. Michelson felt he was given carte blanche—up to a point—in his storyboarding before showing it to Hitchcock: "When he agrees, he makes hundreds of copies—and the make up person knows where to go, and the special effects person knows where to go. I like to give all the information I can, like shadows and costume. I would get together with the costume designer, and I'd like to get to know what they would wear so I could put them in my sketch."

TOP The beginning of the hunt sequence was storyboarded to include exteriors of Rutland's house, Wyckwyn Manor, which were matte paintings by Whitlock. Hitchcock decided to shorten the hunt, so the filming of the horses and hounds on location leaving Wyckwyn was cut.

ABOVE Storyboards of the hunt sequence which were filmed but Hitchcock decided to cut, including the studio shot of Marnie on a horse with rear projection of the hunt filmed on location in Unionville by assistant director James Brown.

MARNIE • Chapter 8

117

THE FOX HUNT

James Brown, who had done a good job filming the bird attack on the school house with the children in *The Birds*, was given the task to film the fox hunt, along with action specialist William Witney, who was the uncredited second unit director. Brown began by first looking for a hunt club, so he contacted Nancy Penn Smith Hannum of Mr. Stewart's Cheshire Hounds, who lived in Unionville, Pennsylvania.

Hannum was a famous Master of Hounds and a formidable character. Mr. Stewart's Cheshire Hounds began in 1912 and hunted in a large area of land, around six thousand acres. The land was originally owned by Lammot du Pont, the head of one of the richest families in America, before being sold to Robert Kleberg of King Ranch, who made it hunting land. The beautiful farmland resembled the English countryside and was inspiring to, and painted by, American artists Andrew Wyeth and George Alexis Weymouth, who also conserved it. Mr. Stewart was Master of the Hounds for years when he married Carol Penn Smith, whose daughter Nancy Penn Smith Hannum later became the Master. Brown persuaded Hannum and fellow riders to take part in the filming, and because it was an Alfred Hitchcock picture, naturally they were delighted. Hannum also recommended two local girls to double for Marnie and Lil.

For the part of Marnie, Susan Cocks was chosen, a twenty-one-year-old blonde who grew up on a farm in Unionville and could ride as soon as she could walk. She was the daughter of William 'Burley' Cocks, a steeplechase trainer and a member of thoroughbred racing's hall of fame. Susan would ride the steeplechase horses, and when they finished racing, she would use them as hunting horses. Sadly Susan died in 2004, but her sister Barbie remembers, "Susie was an excellent rider and I guess she looked enough like Tippi Hedren because she was blonde." She did all the riding scenes for the hunt in November 1963, plus the shot when Marnie is wearing the yellow chiffon dress and jumps over the gate. Because it was so chilly, wardrobe had lined the dress with cashmere. "In that one scene where she's jumping with the horse over the big gate, she did that without a bridle or anything," remembers Barbie. "That's real. She didn't fall off, but she did the one jump and it was a huge gate and the horse was great. [The film crew] said, 'Let's do a couple more!' But Susan said, 'No, I think that will do.' The jump was perfect and it was good enough obviously as it's in the movie."

Lil's part went to another local rider named Patty Boyce from Baltimore. "They were my horses used, which is how I happened to get involved," recalls Patty. "Susan rode my horse which was called Fancidore, and I rode one of Mrs. Hannum's horses." Patty would end up hunting with Mr. Stewart's Cheshire Hounds for the next fifty years and became a board member and close friends with Mrs. Hannum.

The hunting clothes the girls wore were from England, and both Susan and Patty had their own, including the stylish Derby hats instead of the more protective gear which is worn today. When Patty's mother was in England she brought back the riding clothes from the store Wetherall. Most of the riders in the hunt wore English clothes, because they were much better made, as there wasn't a place in the United States that made hunting clothes.

Well equipped with Michelson's storyboards, Brown returned to the hunt country in Pennsylvania on November 16th 1963. Susan and Patty were paid $600 a day for their riding work. Other members of the hunt club involved in the filming included Jonathan Sheppard, who had come over from England, and whose father was in the Jockey Club. Sheppard started working for Susan's father, Burley Cocks, before becoming very famous as a trainer in American thoroughbred horse racing. They all rode with Nancy Hannum as Master of the Hounds. As Patty remembers, "Mrs. Nancy Hannum was just a lovely lady, wonderful manners, she took very good care of everybody in the hunting field. If you had a fall, she would come to the hospital to visit you."

But there was one scene that caused a great deal of debate and that Nancy Hannum wasn't keen to film. In screenwriter Jay Presson Allen's original script, Marnie reacts to the hounds violently tearing the fox apart and identifies with it, as she does in Winston Graham's source novel. Hannum felt that such a scene would draw furore from the anti-hunt

ABOVE Albert Whitlock's matte painting of Wyckwyn integrated with the location filming. Whitlock recalls the second unit asking the riders to file precisely towards camera, to which Hannum replied, "You're spoiling our day!" Although the location filming was shot, Hitchcock decided to cut it and go straight to the hunt in full gallop.

420-1 CONTINUED. SHOT

420 D.2 L.S. HUNT BREAKS INTO FASTER PACE- JUMP FENCES. SHOT

L.S. MATTE. AS DOGS HUNT MOVE PAST CAMERA. SHOT

X-425-1 RIDERS PROFILE TO CAMERA- SHOT

ABOVE Storyboards of the horses and hounds coming to camera with an unused matte painting of Wyckwyn behind designed by Albert Whitlock.

ABOVE Long shots of the hunt which starts the sequence in the final cut of the film after Hitchcock decided to cut the riders leaving Wyckwyn. The extras for the filming were from Mr. Stewart's Cheshire Hounds hunt club.

MARNIE • Chapter 8

119

protesters and animal rights activists. So the script was altered for Marnie to react to the huntsman's scarlet coat instead. It was Hannum versus Hitchcock, and in this instance Hannum won. "You would think you were with Queen Elizabeth, she was the queen of the county around here, and she was one tough cookie," remembers Barbie Cocks. "Nancy would be out there with a machete to clear trails and she was something else. She was up at 5am every morning and went to the barn, and knew all the hounds by name. She was an amazing person."

The storyboards were also altered to reflect the change in the script and an inset included to show Marnie reacting to the close-up of the huntsman's scarlet coat. The hunt's Cheshire hounds rarely killed foxes, as very often the creature would get away from the hounds; the scent became so poor that the huntsmen would call it quits, as the fox would go to ground. Mrs. Hannum would then mark the earth. In a stroke of irony, Susan Cocks herself kept a fox cub called Jamie, who used to live under the family front porch and jump on her arm to be fed. The fox would sire many litters and they knew she was around when the hunt came near to the farm.

However, even before the second unit camera started turning, blood was spilled. Just as the crew was preparing filming for the coming weekend, on Friday November 22nd, President John F. Kennedy was shot in Dallas. He died on his way to the hospital

BELOW Marnie in close-up is a combination of Disney's Rocking Horse and the use of horses on treadmills to simulate riding with rear projection of the hunt behind. In the shots of Lil only the treadmill shots were filmed.

BELOW Long shots of the hunt filmed by the second unit in Unionville by assistant director Brown. Horse riders Susan Cocks and Patty Boyce were the doubles for Marnie and Lil.

in the arms of his wife Jackie. The hunt club, like the rest of the world, was in shock. As Jackie Kennedy used to hunt in Unionville, many of her friends taking part in the hunt were extremely distraught. "Jackie was a very good rider, and she was a friend of all of ours," remembers Patty. Brown recalled, "Many people who were in the fox hunt were close friends of the Kennedys. Mrs. Hannum, the hunt mistress, called me and said, 'We're going to have to cancel.'"

JFK's assassination also impacted filming back at Universal Studios. Script supervisor Lois Thurman remembers, "We were rehearsing and when we heard that he was shot, we closed the set and Hitch sent everyone home and said it was a wrap. Hitch didn't want to work any more." Leon Harris, one of Robert Boyle's storyboard artists, had taken the Friday off to go skiing in Mammoth. When he heard the news that JFK had been killed, he broke his leg and spent the rest of the production sketching boards and illustrations with his leg in plaster. Tippi Hedren, who had met JFK previously when on vacation in the South of France, was driving to her horse-riding lesson in preparation for her role when she learned about the President's assassination. Electrician Paul Jacobsen was working as a lighting grip on the stage of the Rutland offices setting up for the thunderstorm scenes. "I was up high in the deck where the highlights are placed and operated. This was the first time we had used spun glass in front of the lights, which was a diffusion material that softened the harshness of the light beam. I believe it was about lunchtime and one of the production assistants came walking on to the stage, talked to the assistant director and announced that President Kennedy had been assassinated, and everyone milled around in shock." A national day of mourning followed on the Monday, and the studio filming resumed on the Tuesday.

Filming of the hunt was postponed for two weeks because of Kennedy's assassination. This actually turned out to be advantageous for filming, as only 50 riders took part, whereas the 150 who were originally planning to attend would have been difficult for a single second unit to manage. Barbie Cocks, who was on college break, remembers, "Everybody was hunting and having a ball. In the field with the riders galloping across, it was just so much filming. Everyone just jumped on their hunters and went hunting." Following the storyboards, the riders look beautiful in long shot, as well as the English hounds, which are very fast and need a lot of land to run. Today they use the Penn-Marydel American hound.

A helicopter was hired from a nearby aviation center to film the long shot of Marnie emerging from the woods. Patty recalls that for six weeks they couldn't shoot that key aerial shot because it was foggy every morning. When the ground fog finally cleared, "We were told what to do, and go back in the woods and wait until the crew was ready. Susan rode out first, and I ended up chasing her." The two ladies jumped out of the woods over a four-foot fence as the story dictates that Marnie's horse is out of control and Lil is in pursuit. "For the rest of my horse's life, I remember he always made a dash for the nearest fence because that's what he had to do!" jokes Patty.

Years later Boyle recalled the scene: "We had this helicopter and we had a good pilot. But it looked like the damned horse was sailing. It didn't look like a horse jumping at all." Barbie also remembers, "It was so funny, the helicopter flying over our farm, and here the horses are all galloping and jumping, and the helicopter is three feet above them, but they didn't seem to mind."

As the storyboards for the hunt sequence show, there was much more filming than the two minutes of footage which eventually was edited on screen. Patty remembers Brown saying that most of the effort wouldn't be used, partly because *Tom Jones* (1963) had just been released that autumn and featured a spectacular deer hunt on horses. It was just so well done that *Marnie*'s single second unit couldn't compete with the amount of footage that was captured for that sequence.

Another reason for Hitchcock cutting the hunt, especially the scene of the hunters leaving the grounds of Wyckwyn in beautiful procession, was recalled by Whitlock. "We went back into Pennsylvania and we went into the fox hunting country because he wanted to photograph the fox hunt. This is a big contradiction because he was shooting something he didn't want actually. I think he was doing it more because he wanted to be back there. We got involved with the Dupont family—very rich people; all fox hunters—and the house wasn't there of course, it was on the back lot... And we got this long procession with the guy and his bugle and women in their dress, and they were beautifully groomed and everything, and the horses were marvelous. And this particular woman who was the leader of the hunt said, 'You're spoiling our day!' I said, 'But this is a Hitchcock movie. And you're going to come right up to camera; you'll be right in camera. It's going to be a very nice scene,

ALFRED HITCHCOCK'S. 'MARNIE' STUDY FOR MATTE PRODUCTION DES. ROBERT BOYLE.

ABOVE High-angle matte design for Wyckwyn stables with Mark and Marnie walking to the stables from the house. Albert Whitlock painted the final matte.

and in the background there'll be this grand house that's in the movie.'"

After searching the hunt regions extensively for a house that would serve as Wyckwyn, the Rutland residence, Brown chose Wyllpen Farm, the West Chester residence of Mr. and Mrs. William B. Wilson, who also belonged to the hunt club. The exterior was filmed, but only the driveway appeared in the final cut. The front of the house was to be recreated on the Universal back lot and Whitlock was to make a matte painting for the long shot. On November 27th, the day before Thanksgiving, the crew filmed at Wyllpen Farm. Some other scenes were also shot locally, including Nancy Penn Smith Hannum's farm, Brooklawn, on Newark Road in Unionville, and the wall where Marnie has the accident with Forio filmed at the Upland Inn, on the corner of Newark Road and Route 842.

When Whitlock returned to LA he painted the matte shot of Wyckwyn Manor so that the riders could emerge in long shot. He also depicted chase scenes and painted all the backgrounds, so had a whole slew of matte shots ready to use. It took a lot of work and when Whitlock showed it to Hitchcock, he recalls the director saying, "'Oh yeah. Well, we're not using that you know, Al.' So I said, 'What do you mean?' So he said, 'Well, it holds up the story. We don't need the hunt. After all, you know, a fox—we know it's a fox hunt.'"

Hitchcock's view of holding up the story may have been his justification for not trying to compete with *Tom Jones*' extensive footage. Also, Boyle said that Hitchcock was disappointed with the second unit footage that Brown had filmed. "And Hitch didn't like that stuff. So Brown took the brunt, in Hitch's mind, for the whole thing." Despite Hitchcock's misgivings, the hunt sequence was well filmed by both Brown and the hunt club, and Hitchcock later acknowledged to Peter Bogdanovich that Marnie's riding accident with Forio was very effective indeed.

Back at the studio, the close-ups of Tippi Hedren and Diane Baker riding in the hunt were scheduled for the end of filming, just as all the process work was scheduled at the end of *The Birds*. It was common for the rear projection and process to be filmed right at the end when the principal actors such as Sean Connery had departed and any pickups needed could be filmed. The storyboards indicated which shots would be process with the principal actors, and some of these involved the horses on treadmills. Animal trainer Jack Carry was brought into the studio to train the horses to gallop on thirty-foot treadmills over two months. "Boy it was dangerous," recalled unit manager

TOP LEFT Shots of Marnie and the other riders when the fox is brought to ground, a combination of rocking horse and process shots filmed with Tippi Hedren in the studio foreground.

TOP RIGHT Marnie enters the foreground and is horrified to witness the reaction of the riders. The close-ups are a marvelous example of subjective treatment and audience identification with the character.

LEFT Close-up zoom of the huntsman's red coat, which Hannum persuaded Hitchcock to change in the script from that of the fox being torn by hounds.

ABOVE Screenwriter Jay Presson Allen's shooting script for *Marnie* dated October 29, 1963, three weeks prior to the main studio filming of the Rutland offices and location filming of the fox hunt. In shot 434, the original script states that Marnie reacts to the fox being torn apart and there is no mention of the scarlet jacket. Hunt Mistress Nancy Pen Smith Hannum persuaded Hitchcock to change the script.

MARNIE • Chapter 8

123

Hilton Green. "If the horse fell off the treadmill it could have broken its leg."

Tippi Hedren said at the time, "For the last three weeks we have been using a treadmill, then we went to this thing which was invented by Walt Disney and for close-up… It's a box and they want it to look like the horse is at a canter so it's a rocking chair." This shot is marked as "Rocking Horse" in the storyboards. Both Hedren and Baker rode in front of process plates, which is rear projection of the hunt club filmed on location. Unlike blue screen, there are no matte lines with rear projection as the shooting camera is in sync with the projector screen, linking the two.

Despite Hitchcock's cavalier attitude to dropping many of the matte shots that Whitlock designed and what Brown shot for the hunt sequence, both Green and Brown remarked that Hitchcock preferred shooting indoors because of his ability to control. "Hitchcock loved matte shots," said Green. "He loved to make the audience wonder how did they get that shot? Too bad he just missed the new technology which came right after he died as everything changed. But he would have loved using CGI." The use of mattes in the storyboarding process would be brought to an even greater level of artistry in Hitchcock's next film, the Cold War spy thriller *Torn Curtain*.

BELOW LEFT Marnie in the foreground filmed in the studio with Tippi Hedren on the treadmill. In the background are the process plates of the riders' reaction to having caught the fox.

BELOW Shots of Lil on treadmill in the foreground, while the background shot of Marnie galloping away was filmed on location with Susan Cocks as Marnie's riding double and Patty Boyce doubling for Diane Baker.

ABOVE Matte design for the exterior of the Rutland publishing offices in Philadelphia just before the thunderstorm. In the foreground Marnie walks into the office on a Saturday afternoon. Albert Whitlock painted the final matte.

BELOW An extreme long shot of the interior stables at Wyckwyn just before Mark kisses Marnie. The design is for a matte painting by Albert Whitlock.

CAST AND CREW

Paul Newman
Professor Michael Armstrong

Julie Andrews
Dr. Sarah Sherman

Lila Kedrova
Countess Kuchinska

Hansjoerg Felmy
Heinrich Gerhard

Tamara Toumanova
Ballerina

Ludwig Donath
Professor Gustav Lindt

Wolfgang Kieling
Hermann Gromek

Günter Strack
Professor Karl Manfred

Mort Mills
Farmer

Carolyn Conwell
Farmer's wife

Director
Alfred Hitchcock

Screenplay
Brian Moore

Cinematography
John F. Warren

Film Editing
Bud Hoffman

Production Design
Hein Heckroth

Assistant Director
Donald Baer

Art Director
Frank Arrigo

Pictorial Designs
Albert Whitlock

Art Department
Joseph Musso (Production Illustrator; uncredited), Mort Rabinowitz (Set Illustrator; uncredited)

Chapter 9

TORN CURTAIN

"Hitchcock liked to have an illustrator in his pocket."

— Joseph Musso, production illustrator

PLOT SUMMARY

Professor Michael Armstrong and girlfriend Dr. Sarah Sherman are in Copenhagen for a physicists conference. Michael behaves suspiciously and Sarah follows him beyond the Iron Curtain to East Berlin. He apparently defects and is welcomed by the head of security Heinrich Gerhard. Sarah is appalled by Michael's behavior until he reveals that he is acting as a US double agent to extract information about a secret anti-missile formula. Michael travels to a remote farmhouse to meet the farmer who is an operative of Pi, an underground network who will help him escape once he's retrieved the information. But he is followed by German security officer Gromek, who realizes that he is a double agent working with Pi. Michael and the farmer's wife manage to kill Gromek by stabbing him and putting his head in a gas oven. At Karl Marx University in Leipzig, Michael extracts the secret formula from Professor Lindt, and with the help of Pi, escapes with Sarah on a decoy bus en route to East Berlin. The real bus catches up with them, but before they are caught by the Stasi, all the bus passengers escape. Michael and Sarah meet Countess Kuchinska, who threatens to expose them unless they help her. After escaping the authorities once more, the couple are spotted at a ballet by the lead ballerina, who recognizes them in the audience and alerts the Stasi. Michael manages to cause a distraction by shouting fire, creating pandemonium in the theater, allowing the couple to escape. They travel, smuggled by ship to Stockholm, and make it safely back across the Iron Curtain.

Two big movie stars, Paul Newman and Julie Andrews, featured in Hitchcock's fiftieth film, *Torn Curtain*. Hitchcock was intrigued by the Guy Burgess and Donald Maclean case about British spies defecting to Russia. His thought was, what would Mrs. Maclean think? Although not as well received as *North by Northwest*, *Psycho*, and *The Birds*, *Torn Curtain* nonetheless has a number of stylish set pieces and careful storyboarding that shows that even lesser Hitchcock is better than most movies today.

When *Torn Curtain* went into production in the summer of 1965, Hitchcock's production base at Universal Studios was a well oiled machine. He had his own unit housed in the bungalow, plush and well appointed, which had a commanding position in the Universal lot and which was split in half. One half was the art department, and the other half was for editorial, allowing the storyboard artists to walk over and confer with the editors. Hitchcock had his staff, writers, editors, and screening room just off the hallway, where he would often screen foreign films, and he could walk up and down the hall and see whoever he wanted. The art department at Universal as a whole was a very busy place at the time.

TOP & ABOVE LEFT Concept illustrations by Mort Rabinowitz for the East Berlin museum with Michael Armstrong walking through the galleries while being followed by Gromek.

ABOVE MIDDLE High-angle concept illustration by Mort Rabinowitz for the East Berlin museum with Michael Armstrong walking through the gallery over the marble floor while being followed by Gromek.

ABOVE RIGHT Concept illustration by Mort Rabinowitz for the East Berlin museum with Michael Armstrong running down the steps towards an exit.

HEIN HECKROTH

To create the production design of *Torn Curtain*, which was mainly set in East Berlin, Hitchcock invited Hein Heckroth, the art director of stage and screen. Born in Hesse, Germany in 1901, Heckroth studied at the Städel art school in Frankfurt and had ambitions of being a painter. After school, he started with the experimental Kurt Jooss dance company and would design a number of ballets concentrating on stage design. Jooss' Expressionist performance, along with Surrealism, influenced Heckroth.

Like Oscar Werndorff, the art director for *The 39 Steps* before him, Heckroth was an émigré, who moved to England in 1935. There he designed the sets for *A Matter of Life and Death* (1946), *Black Narcissus* (1947), and *The Red Shoes* (1948), the latter for Michael Powell and Emeric Pressburger, for which he won an Academy Award® for Best Art Direction. Heckroth had designed over six hundred sketches for the ballet alone, and his abstract sketches were full of mood and color.

Hitchcock chose Heckroth because he wanted a designer who knew the European look of the film, with locations such as the Alte Nationalgalerie. Heckroth was familiar with East Berlin, and the sets all had to be built and designed at Universal Studios. But Heckroth was also one of the top theatrical ballet designers in Europe at the time, and a pivotal scene towards the end of *Torn Curtain* is at the ballet, so Hitchcock needed a theatrical designer. Heckroth had the theater credentials behind him, and because of his experience as a sort of renaissance man, he could do it all. Hitchcock felt very comfortable working with him.

Working with Heckroth was Frank Arrigo, art director, who was borrowed from Universal's art department, as was Jack Corrick, the production manager. Once again, Albert Whitlock was the matte painter supervising the pictorial design, plus there were a couple of storyboard illustrators who supported the production with their sketches, Mort Rabinowitz and Joseph Musso.

LEFT Hein Heckroth, German art director of stage and film. Courtesy of Jodi Routh.

ABOVE Production sketch by Joseph Musso showing the office of Heinrich Gerhard with the bombed-out ruins of East Berlin behind, as a reminder of the destruction war creates. Hitchcock asked for a very severe, modern, and austere feel for Gerhard's office. Courtesy of Joseph Musso.

JOSEPH MUSSO

One of the youngest members of Universal's art department was storyboard artist Joseph Musso, who had graduated from the University of the Arts in Philadelphia with a Fine Arts degree. In 1964, a year before *Torn Curtain*'s production, twenty-three-year-old Musso gained his first job as a storyboard artist on *Marriage on the Rocks* (1966) at Warner Bros., followed by *Who's Afraid of Virginia Woolf?* (1965). Then he began at Universal Studios where he would spend the next fifteen years. Assignments included working with art director Frank Arrigo on episodes of the *Run For Your Life* television series. For *Torn Curtain*, it was Musso's first time working with Alfred Hitchcock, with Arrigo as art director, and Hein Heckroth as the production designer.

"I worked with [Hitchcock] for about eight months on the film and out of his offices," remembers Musso. "He was a very hands-on person. I had a little cubicle that I worked in with a drawing table and I was right down at the end of the hall, so he could walk down and look over my shoulder and watch me paint. That was the artist in Hitchcock. He treated you like his family."

Hitchcock wanted to have sketched conceptual designs of all the different sets, as most of them had to be built. Musso drew movement storyboards of how the actors walked through the sets. Some of the sketches that Hitchcock wanted were in color, so he could see what the background would look like. Musso worked quickly, preferring to use poster paints. During this time, Xerox and other copying machines were still not capable of reproducing fine, detailed illustrations yet, so those working in the studio art departments had to rely on blueprint types of machines. Drawings were etched on a transparent paper so the camera light could shine through, and printed on a paper that reproduced the image in a blue, black or sepia line.

Presentation sketches were usually printed in sepia and dry-mounted on a heavier illustration board or mounting cardboard. To accommodate this system, the production illustrators did their black and white sketches in charcoal, ink, or graphite pencil on 1000H transparent drafting paper, vellum, or yellow tissue tracing paper. "When need be, we would occasionally apply pastel on the back of the tissue paper to give our illustrations some color," says Musso. "The same was true for our black and white storyboards, or continuity sketches as we used to call them—they all had to be done on a transparent paper, so that they could be run through the blueprint machine and printed out on 8.5 by 11 inch blueprint paper."

As *Torn Curtain* was a Cold War spy thriller, Hitchcock wanted a definite change in color mood. In Copenhagen and West Berlin it was very bright. But in East Berlin the color palette was in all different shades of gray. "The walls in the airport, he wanted a gray brick," remembers Musso. "And Hitchcock picked out the shade of gray. When I was painting it, I thought it was a flat wall, and to give it a little character, I varied the shade of gray, just a little bit, a tad here and there, just to give it some interest." When Hitchcock came in and saw the sketch he loved it. The greyness characterized the bleakness of the characters at the time, which Hitchcock accentuated by filming Michael and Sarah in single shots, never together during the airport scene, to emphasize their growing detachment.

In the hotel room, when Michael has seemingly defected and is emotionally distant from Sarah, the camera angle is strikingly composed. "There was one very effective sequence in the film that I purposely played entirely in long shot," said Hitchcock. "It took place in that East Berlin hotel room where we had the evening sun shining in—just a faint yellow shaft of warm sunlight; the rest was that awful heavy brown, a mood effect. That sequence represents very close coordination between the visual conceptions of the production designer and the cameraman. The lighting, and the color of the light, work in relationship to the somber tones of the room."

Musso remembers sketching in August and September 1965, while filming continued in October, and he was still sketching and working on other scenes when filming began. "Basically I was working up to the end and still doing storyboards of sketches and these sequences and plotting things out. It was a real pleasurable experience at the time. I basically worked until the end of the filming until

THIS IMAGE Designs for Albert Whitlock's matte paintings. Matte sketches in fine line perspective for the East Berlin museum with Michael Armstrong walking through the galleries while being followed by Gromek. In the high-angle shot, Paul Newman was asked to walk on marble paper to stay within the live-action section of the matte. Brownline sketches mounted on black illustration board

the last roll went through the can." He would spend a week ahead sketching and plotting scenes out, before the crew were going to film, and was kept right onto the end of filming, because at the last moment the production may need something. This pattern of the storyboard artist working through production is similar to Harold Michelson's experience on *The Birds* and *Marnie*. As Musso surmises, "Hitchcock liked to have an illustrator in his pocket."

Only certain scenes were storyboarded, as assistant director Donald Baer recalls: "The whole film was not storyboarded, but the main sequences were laid out." This included scenes where matte paintings were involved, and once again Albert Whitlock, who had created the mattes for *The Birds* and *Marnie*, was called upon. Whitlock painted matte background scenes of East Berlin, especially for the sequence where Armstrong tries to escape from Gromek, his German shadow, by running into an art museum.

Heckroth scouted the Alte Nationalgalerie in East Berlin, which was used as the basis for the museum. Heckroth gave excuses to the Volkspolizei of why he started, with a wooden folding measuring stick, to map out the main hall. As he had a British passport, he was allowed to visit East Germany as a tourist. "It ended, as far as I know, with him buying a lot of black and white postcards and carrying on from there," says Heckroth's grandson Jodi Routh.

"And we had to design the interiors of this Berlin art museum as we couldn't go over to film it," states Musso. "It really relied on Albert Whitlock's matte paintings—and Whitlock had to do six or seven matte paintings back to back. And we filmed on the Universal parking lot and off the main street into the museum. What we did off the main lot was build a doorway, so when Paul Newman goes into the museum into the whole rest of the scene, that was all a matte painting."

The chase sequence in the museum was carefully storyboarded to be a mixture of live action, set interiors and matte paintings. Hitchcock designed a high-angle shot with the camera looking down into the exhibition galleries. The audience sees the pillars and the beautiful marble floor, which Michael Armstrong runs across as Gromek follows him. Hitchcock builds suspense with the sound of echoing footsteps. Mort Rabinowitz, the other illustrator working with Joseph Musso, drew four concept storyboards in color. Production illustrations of the mattes were also drawn as fine line perspective studies prior to Whitlock's detailed matte paintings. So by the time it came to filming the museum sequence it had all been carefully illustrated and planned out.

"I was there, along with Hitchcock, Hein Heckroth, Frank Arrigo, and Mort when the angles were selected to show in Al's mattes, after which we consulted with him," Musso states. "Mort then did some loose color illustrations on these angles, hence the necessity for Al to do some detailed line perspective studies before proceeding with his finished matte paintings. When Al initially saw the entire sequence that we dreamed up, he balked at having to do a group of matte paintings so close together, saying, 'Hitch, I know what I'm doing and it won't work.' To which Hitchcock replied, 'Well, at least you can try.'" Whitlock gave it his all and did a brilliant job on the sequence, and was so pleased with it, it led his presentation portfolio film reel

thereafter. But he always gave Hitchcock credit for bugging him to do it.

However, when Paul Newman arrived on the set to begin filming he balked. "Well, Newman expected to see this elaborate set on the sound stage," says Musso. "When he goes on the stage, all he saw was this sheet of marble paper running across the stage floor. Hitchcock told him to walk fast. Newman looked at him and said, 'What's my motivation for running on this paper?' And Hitchcock looked at him and said, 'Well, if you don't stay on the marble paper, you're going to disappear under the matte and nobody is ever going to see you.' Newman had to do it, and of course when you see it on film, it's a magnificent high angle across the beautiful marble floor followed by Gromek. It was all Hitchcock."

To design the matte Whitlock would set up the camera shot that was supposed to be the painting. In the area that was going to be a matte, he would shoot some footage ahead of time. Then he would take his measurements and begin the painting. Whitlock used oil paints on glass, because as glass is smooth, he achieved finer brush strokes for a really soft blend. The mattes were very realistic as Whitlock believed that a good matte "shouldn't draw attention to itself." The production also used scenic backings to show the ruins of East Berlin, as Hitchcock wanted to emphasize the bombed-out ruins overlooking the museum, and mark the contrast between the new mayhem and reminders of the old mayhem. Hitchcock was keen to show this: In the background of the shot when Newman runs out of the art museum having escaped Gromek are all the old ruins of the Alte Nationalgalerie, which had been damaged by bombing during the war.

Musso remembers that unlike Walt Disney, who would have storyboards photographed on boards and then wheeled onto the set, Hitchcock would not. On some occasions the original storyboards or conceptual sketches would be on the set to refer to, and some of them could be very complex. "Some of the conceptual sketches I did were big storyboards… and some of the other smaller ones which I did in between would be there. I had to paint very fast too, mixing casein paint, which dries very quickly."

Occasionally Hitchcock asked Musso to storyboard for camera placement, but more often Hitchcock would know precisely where he wanted the camera to be. As Musso was familiar with twenty- to seventy-inch lenses, he could figure out camera height and knew when to raise or lower the camera. Another person who benefited from Hitchcock's knowledge of lenses was Julie Andrews, who played Sarah Sherman. "[Hitchcock] was very kind to me," remembers Andrews. "One day he told his cameraman off for using a lens that was inappropriate on me and said, 'On a woman you're going to use this.' And I confessed I didn't know very much about lenses—and he said, 'Come with me…' and for about half an hour drew designs and lenses and, 'Don't ever let them use this on you because your nose will go out to there.' He couldn't have been kinder."

OPPOSITE & BELOW Designs for Albert Whitlock's matte paintings of the East Berlin shot of Michael Armstrong walking through the museum gallery and down a flight of steps, where he manages to exit the building and lose Gromek. Brownline sketches mounted on black illustration board

ABOVE The latent image matte shot showing the studio filming and live action. The black mattes are areas of the glass that Albert Whitlock would replace with paint. During the shoot Paul Newman was asked to walk along a very definite line along the marble floor during the museum chase.

GROMEK IN PURSUIT

One of the most famous and celebrated sequences is the killing of Gromek. The farmhouse was located in Camarillo, which is further out of Los Angeles County, chosen for its flat land to resemble Germany. "We picked a farmhouse there and the irony is, just before we got to shoot it, we had two weeks of rain which really came down," remembers Musso. Afterwards the smog had lifted, and there were mountains in the background which the production was unaware of. Suddenly it looked like a farmhouse in Southern California rather than in East Berlin, so the production had to shoot around it when it had stopped raining.

Interestingly, the fight inside the farmhouse when Armstrong and the farmer's wife try to kill Gromek wasn't storyboarded. Hitchcock wanted to show just how hard it is to kill a person in real life as it was often portrayed as easy in the movies. "And of course Newman being Newman wanted to give a John Wayne punch and knock him out," remembers Musso. "Hitchcock had to remind him, 'You're a scientist, not a prizefighter,' and he wanted it to look very real. Newman was fumbling around and the farmer's wife tries to help him, gets him over to the stove. Newman wasn't happy because he looked like a bumbler in it, but that's exactly what Hitchcock wanted." The farmhouse scene is also another fine example of Hitchcock using his locations to the fullest. A knife, a shovel, and finally a gas oven are the tools to kill Gromek, all of which are found in a farmhouse kitchen.

THE BALLET

Like Gromek's killing, Hitchcock filmed the climactic theater ballet with two cameras, one on a rig and the other handheld. The whole stage performance was choreographed by Heckroth because of his background in German ballet, including working with the famed dancer Kurt Jooss on *The Green Table*. Heckroth coordinated all the costumes and sketches for the ballet, which again is integral to the plot as the papier-mâché ribbon flames on stage give Armstrong the idea of shouting 'fire' to escape the Stasi. Highly decorative, and with striking symbolism and Surrealist images, the performance of Francesca da Rimini is offset by a sumptuous red background echoing the descent into hell. Jodi Routh, Heckroth's grandson, believes Surrealism has always featured heavily in Heckroth's work: "As to the influence of Jooss on Heckroth's work, there was over forty years, a war, and a restart in life at Dartington Hall in Devon; between *The Green Table* and *Torn Curtain*, his Expressionist Surrealism was, in all his designs and paintings, always present."

The set used for filming was Universal Studios' Stage 8, which had been designed for *The Phantom of the Opera* (1925) and was the oldest standing set in Hollywood. The interior was classic European style, a three-tiered box seat horseshoe theater and stage. All the drawings from *The Phantom of the Opera* had long since gone, but Musso collected ten scene stills from the film and was able to pick out molding details, which the art department recreated for *Torn Curtain*. It was magnificently restored thanks to the production. They even brought in a chandelier to hang overhead as Hitchcock wanted the set to look as authentic as it could be. Musso would sketch storyboards for a 50mm lens, the lens of the human eye, unless he was told to use something different, like a 40mm.

The theater is another great example of Hitchcock using his locations to advance the plot. When pandemonium ensues, Musso remembers that Hitchcock wanted five hundred German-speaking extras, so when the fire broke out, followed by the melee, people would be running around uttering things in German and not English. Hitchcock wanted that realistic effect. In his research he also made the same geographical trip as the characters, starting in Copenhagen and flying to East Berlin, to Leipzig, and then back to East Berlin and finally to Sweden from where the couple escape. Despite the lack of first unit shooting in East Berlin, through Hein Heckroth's production designs and Albert Whitlock's matte paintings, Hitchcock's fiftieth feature is a sombre portrayal of life behind the Iron Curtain.

Conclusion

Topaz (1969) & *Family Plot* (1976)

After *Torn Curtain*, Hitchcock would make three more films, *Topaz*, *Frenzy* (1972), and *Family Plot*. Each film is distinctly different in tone, subject matter and location, but what they all have in common is the meticulous preplanning and storyboarding. They were all Universal productions, but *Frenzy* was filmed on location in London, whereas *Topaz* and *Family Plot* were filmed at Universal Studios with some location shooting.

For the latter two films, the storyboard illustrator was Thomas J. Wright, who had studied art for four years at the Chouinard Art Institute in LA, graduating top of his class. He started work at Universal Studios as a storyboard artist and as a production illustrator on television series such as *Night Gallery*. He first began working with Hitchcock on *Topaz*. "It was a great experience, we got along very well," affirms Wright. "Hitchcock invited me into his office in the afternoons for a drink and snack, often under the pretext of having a meeting, and he would tell great stories."

On *Topaz*, Wright worked with production designer Henry Bumstead, who was once again reunited with Hitchcock after filming *Vertigo* together ten years earlier. Wright would draw his storyboards in ink on the page and is a firm advocate for using them: "Storyboards are an excellent guide, they are like taking notes. You have them in picture form and they are much easier to see and read." He would also draw production illustrations when he had time to do so, because Hitchcock liked having them to refer to. Wright would use a whole palette of acrylic paints for his illustrations and remembers one sequence towards the end of *Topaz*, where the American and French agents meet in a big conference room and Jacques Granville (Michel Piccoli) is asked to leave. Hitchcock wanted a streak of white light on the floor, which would cast long shadows from the figures standing in the room. He couldn't get enough white light on the floor to shine, so the production ended up painting the floor. The result was very effective in the final film.

Wright was asked by Hitchcock to direct some second unit, mainly the action sequences. "Hitchcock said, 'Would you mind doing these scenes?' which I then directed," Wright remembers. "I went off and storyboarded the script. Hitchcock would look at it and I went out and filmed with the second unit." Some of the scenes that Wright directed include the crowd scenes involving the Cubans, both in Harlem and in Cuba, which involved stunt coordination.

Despite being often criticized as one of Hitchcock's lesser works, Wright believes that Hitchcock was invested in *Topaz*, and the film has a lot more color to it than it is usually credited for. As Wright had ambitions of being a director, Hitchcock generously sponsored him into the Directors Guild of America and encouraged Wright to direct the action sequences.

The famous shot that *Topaz* is well remembered for was carefully storyboarded by Wright, namely the murder of Juanita de Cordoba (Karin Dor) by her Cuban lover Rico Parra (John Vernon). "It was shot on a crane, and Hitchcock laid out the final position

THIS IMAGE The celebrated cemetery chase sequence for *Family Plot*, storyboarded by Wright. As Wright wanted to be a director, Hitchcock allowed him to film some second unit action scenes, and was a mentor for Wright, sponsoring him into the Directors Guild of America.

of [Juanita] that he wanted, then we shot the scene," says Wright. "Hitchcock liked the high shot, and after we storyboarded, he laid it out for the actors and camera. Once we had the storyboards, it was locked in and Hitchcock didn't tend to improvise."

Actress Karin Dor remembers that the production was shooting in Florida to stand in for Cuba, and the production design, led by Henry Bumstead, brought in palm trees from Cuba to make it look more authentic. Hitchcock had everything planned for the death scene, Dor recalls: "Hitchcock said, 'I want to see you falling in a pool of blood.' The [purple] dress was kind of a jersey, and they tried hours with a stand-in. They put wires on the seam of the dress, and at every end there was a technician who pulled the wires and the dress splayed out. There was an overhead camera to film." When Parra shoots Juanita, the purple dress splays out like a flower in the overhead shot; although it was a death scene, Hitchcock wanted it to look very beautiful.

Other notable sequences in *Topaz* hark back to Hitchcock's roots in silent cinema. The bribery of the Cuban secretary Uribe (Don Randolph) by the French agent Philippe Dubois (Roscoe Lee Browne) is shown in longshot from across a New York Harlem street. The audience, along with Andre Devereaux

(Frederick Stafford) can see but not hear what's happening, but through the body language of the actors can deduce Uribe is being bribed. Similarly, in the flower shop scene beforehand, Dubois and Devereaux discuss their plans in long shot through a pane of glass; the audience can see them but not hear what they are saying.

After *Topaz*, Wright worked as a production illustrator on *The Andromeda Strain* (1971), *Diamonds are Forever* (1971), and *Jaws* (1975), before being reunited with Hitchcock for the director's last film, *Family Plot*. Most of the scenes were filmed around Los Angeles and on the Universal sound stage, with some filming in San Francisco, such as Grace Cathedral.

"We took the actors on location," remembers Wright. Once the locations had been chosen, the film crew went up and shot the scenes according to the storyboards. Once in a while Hitchcock would change a few things, and some of the shooting he would hand over to Wright to shoot, such as the action scenes and the runaway car, all of which had been carefully laid out according to the storyboards. Some of the famous layouts that Wright drew for *Family Plot* include the kidnapping of the bishop and the pursuit scene in the cemetery where George Lumley (Bruce Dern) follows Mrs. Maloney (Katherine Helmond).

"Hitch always had two or three things which he was very adamant about," remembered Henry Bumstead. "In *Family Plot*, he was very adamant about the very high shot in the cemetery." Hitchcock remarked he was very interested in the intersection between divergent characters, which was one of the reasons for making *Family Plot*, and the overhead shot in the cemetery diagrammatically summarises that idea. Leonard South was the cinematographer for *Family Plot*, and had been working as a camera operator for Hitchcock since *Strangers on a Train*. South wanted to see the storyboards and he knew how they would work for Hitchcock. South remembers that sometimes Hitchcock would have the storyboards redrawn to fit his own cutting continuity, or he would wait until he was on the set and draw them in the margins of the lined script. The storyboards were also a point of reference for the film's editor, J. Terry Williams. "I'd talk to him about this cut, just between he and I. Hitchcock would have his own views, would come in and be prepared," says Wright. Like *Topaz*, *Family Plot* isn't regarded as one of Hitchcock's best films, but right until the end of his career, storyboarding and art direction were paramount in the success of his films.

It is an incredibly exciting time to be a content creator today, as the wealth of mobile devices and apps makes it very easy to upload videos and share content. The acceleration of content marketing also embraces video and the visual medium and consumers often prefer to watch rather than read. That is where storyboarding can help. The aim of content creators is to entertain and tell a good story: "What is drama, after all, but life with the dull bits cut out," said Hitchcock.

As Hitchcock superbly demonstrated, perhaps better than anyone else, storyboards are a visual screenplay and serve as a blueprint for the cameraman and other members of the production. They can be a major contribution to a successful film or content creation. Planning is essential for expressing ideas and sharing them, which can save time and money. Through storyboarding, Hitchcock created his own worlds, hopes, and fears; and these are reflected in the storyboards, expressing the creativity of the director and clarifying to those involved an explanation of the scene and the content itself. Hitchcock used this device very successfully throughout his films, notably in *Psycho*'s shower murder, the murderous crows silently gathering on the jungle gym by the school house in *The Birds*, and the chase up the bell tower in *Vertigo*.

All storyboards can help with preplanning and execution, whether they are thumbnail sketches like Alfred Hitchcock's drawings, beautiful watercolor washes like Dorothea Holt's, charcoal sketches like Mentor Huebner's, Harold Michelson's suspense boards, or the elaborate watercolor or pen-and-ink drawings by Joseph Musso and Thomas Wright. Storyboards elevate an artist's work, whether it is by thinking about the lighting source, designing sets in the studio such as Oscar Werndorff, planning elaborate shots like Henry Bumstead in *Vertigo*, or with the editing in mind such as Saul Bass. It all goes back to the rectangle to fill, as Hitchcock remarked, with a succession of images—and that's what makes a memorable film.

Fin

GLOSSARY

Art Director
The person who manages the creative team, plans the sets and has a knowledge of architecture.

Art Direction
The control over what the audience sees on the set.

Back Projection
Plates that combine foreground performances with pre-filmed background scenes.

Big Head
Hitchcock's favorite expression for an extreme close-up.

Choker Shot
A version of the extreme close-up, usually framed at just above the eyes and just below the mouth.

Concept Drawings
Sketches drawn freehand to give initial ideas.

German Expressionism
Twentieth century art movement that emphasized feelings over reality.

Matte Painting
A painting of the landscape or environment to give the effect of background.

Montage
Juxtaposition of individual shots or frames to convey ideas.

Mood Boards
A collage of sketches or images to create a general feeling.

Sodium Vapor
Photochemical technique of combining actors with background.

Storyboard
Shot-by-shot description of how content will unfold, often broken down into a series of panels.

Previsualization
Mapping out scenes of content before it is filmed.

Production Designer
The person responsible for the visual concept of a film.

Production Illustrator
The person whose task is to draw a working storyboard and detailed sketches of shots that make the film.

Production Sketch
Artwork often used to show the creative team the final concept.

Set Dresser
The person who furnishes the set.

FILMOGRAPHY & INDEX

Feature films on which Alfred Hitchcock [AH] worked as Assistant Director / Director.

Number 13 (1922, unfinished)
Famous Players-Lasky
AH: Producer; Assistant Director

Always Tell Your Wife (1923)
Seymour Hicks Productions
AH: Assistant Director (uncredited)
Page 7

Woman To Woman (1923)
Balcon-Saville-Freedman
AH: Writer; Art Director; Assistant Director
Pages 7, 12

The White Shadow (alt. *White Shadows*; 1923)
Balcon-Saville-Freedman
AH: Writer; Editor; Production Designer; Art Director; Set Decorator; Assistant Director

The Passionate Adventure (1924)
Gainsborough
AH: Writer; Art Director; Assistant Director

The Blackguard (1925)
UFA, Gainsborough
AH: Writer; Art Director; Assistant Director
Pages 12, 47

The Prude's Fall (alt. *Dangerous Virtue*; 1924)
Balcon-Saville-Freedman
AH: Writer; Art Director; Assistant Director

The Pleasure Garden (1926)
Gainsborough, Emelka GBA
AH: Director
Page 13

The Mountain Eagle (1926)
Gainsborough, Emelka GBA
AH: Director
Page 13

The Lodger: A Story of the London Fog (1926)
Gainsborough
AH: Director

Downhill (alt. *When Boys Leave Home*; 1927)
Gainsborough
AH: Director

Easy Virtue (1927)
Gainsborough
AH: Director

The Ring (1927)
British International Pictures
AH: Writer; Director

The Farmer's Wife (1928)
British International Pictures
AH: Writer; Director

Champagne (1928)
British International Pictures
AH: Writer; Director

The Manxman (1928)
British International Pictures
AH: Director

Blackmail (1929)
British International Pictures
AH: Writer; Director

Juno and the Paycock (alt. *The Shame of Mary Boyle*; 1930)
British International Pictures
AH: Writer; Director

Elstree Calling (1930)
British International Pictures
AH: Director

Murder! (1930)
British International Pictures
AH: Writer; Director

Mary (1930)
British International Pictures
AH: Director

The Skin Game (1931)
British International Pictures
AH: Writer; Director

Number Seventeen (1932)
British International Pictures
AH: Writer; Director

Rich and Strange (alt. *East of Shanghai*; 1932)
British International Pictures
AH: Writer; Director

Waltzes From Vienna (alt. *Strauss's Great Waltz*; 1934)
A Tom Arnold Production
AH: Director
Page 30

The Man Who Knew Too Much (1934)
Gaumont-British
AH: Director
Pages 31, 58

The 39 Steps (1935)
Gaumont-British
AH: Director
Pages 13, 17, **20-31**, 110, 129

Secret Agent (1936)
Gaumont-British
AH: Director
Page 31

Sabotage (alt. *The Woman Alone*; 1936)
Gaumont-British
AH: Director
Page 31

Young and Innocent (alt. *The Girl Was Young*; 1937)
Gainsborough
AH: Director

The Lady Vanishes (1938)
Gaumont-British
AH: Director
Page 31

Jamaica Inn (1939)
Mayflower Pictures
AH: Director

Rebecca (1940)
Selznick International
AH: Director
Pages 36, **38-40**, 41, 43, 46, 50, 65, 100

The House Across the Bay (1940)
Walter Wanger/United Artists
AH: Director (uncredited)

Foreign Correspondent (1940)
Walter Wanger/United Artists
AH: Director
Pages 14, 50

Mr. & Mrs. Smith (1941)
RKO
AH: Director

Suspicion (1941)
RKO
AH: Director
Page 46

Saboteur (1942)
Frank Lloyd/Universal
AH: Writer, story (uncredited); Director
Pages 13, 14, 15, 36, 43, 71, 101

Shadow of a Doubt (1943)
Universal/Skirball Productions
AH: Director
Pages 13, 17, 19, **32-43**, 46, 71

Lifeboat (1944)
20th Century Fox
AH: Director
Page 46

Bon Voyage (1944)
Phoenix, for the British Ministry of Information
AH: Director

Aventure Malgache (1944; Released 1993)
Phoenix, for the British Ministry of Information
AH: Director

Spellbound (1945)
Selznick International
AH: Director
Pages 17, **44-53,** 56, 65, 101, 116

Notorious (1946)
RKO
AH: Writer (uncredited); Producer (uncredited); Director
Page 12

The Paradine Case (1947)
Selznick International/Vanguard
AH: Director

Rope (1948)
Transatlantic
AH: Producer; Director
Pages 36, 43

Under Capricorn (1949)
Transatlantic
AH: Producer; Director
Page 38

Stage Fright (1950)
Warner Brothers/First National
AH: Producer; Director

Strangers on a Train (1951)
Warner Brothers/First National
AH: Producer; Director
Pages 56, 72, 139

I Confess (1953)
Warner Brothers/First National
AH: Producer; Director

Dial M for Murder (1954)
Warner Brothers
AH: Producer; Director

Rear Window (1954)
Paramount/Patron, Inc.
AH: Producer; Director
Pages 14, 36, 43, 67, 104

To Catch a Thief (1955)
Paramount
AH: Producer; Director
Pages 36, 43, 58

The Trouble with Harry (1955)
Paramount/Alfred Hitchcock Productions
AH: Producer; Director
Pages 14, 56

The Man Who Knew Too Much (1956)
Paramount/FilWite Productions
AH: Producer; Director
Pages 14, 16, 36, 43, 58, 104

The Wrong Man (1956)
Warner Brothers
AH: Producer; Director

Vertigo (1958)
Paramount/Alfred Hitchcock Productions
AH: Producer; Director
Pages 8, 13, 14, 17, **54-67**, 88, 101, 137, 139

North by Northwest (1959)
MGM
AH: Producer; Director
Pages 7, 8, 14, 17, 18, 38, **68-85**, 88, 101, 128

Psycho (1960)
Paramount/Shamley Productions
AH: Producer; Director
Pages 7, 14, 18, 38, 56, 62, **86-97**, 100, 101, 104, 116, 128, 139

The Birds (1963)
Universal/Alfred Hitchcock Productions
AH: Producer; Director
Pages 7, 14, 18, 31, 38, 71, **98-113**, 116, 117, 118, 122, 128, 132, 139

Marnie (1964)
Universal/Geoffrey Stanley, Inc.
AH: Producer; Director
Pages 14, 18, 46, 65, 71, **114-125**, 132

Torn Curtain (1966)
Universal
AH: Producer; Director
Pages 7, 17, 18, 116, 124, **126-135**, 137

Topaz (1969)
Universal
AH: Producer; Director
Pages 18, 67, 137, 138, 139

Frenzy (1972)
Universal
AH: Producer; Director
Page 137

Family Plot (1976)
Universal
AH: Producer; Director
Pages 14, 16, 67, 71, 137, 138, 139

ACKNOWLEDGMENTS

Thank you to Leland Faust of Taylor & Faust for allowing us to publish from the Alfred Hitchcock Files at the Margaret Herrick Library, Academy of Motion Picture Arts and Sciences. Also thank you to Genevieve Taylor and Kristine Krueger for access and reproduction of the artwork at the Margaret Herrick Library.

For *The 39 Steps* artwork we thank Espen Bale and the British Film Institute for access and reproduction of the storyboards.

Thank you to the Harry Ransom Center, at the University of Texas at Austin for consultation of the David O. Selznick and Ernest Lehman files.

Thank you to Lee Redmond and Lynne Jackson for permission to reproduce the artwork from Dorothea Holt and for the photograph of their mother. Also thanks to Margaret McClellan for sharing her memories of interviewing Dorothea Holt.

The Dali artwork is reproduced with permission from the Fundació Gala-Salvador Dali organization by arrangement with DACS.

Thank you to Sara Cochran for her interpretations of the Salvador Dali dream sequence.

Bob Bumstead gave permission to reproduce his father Henry Bumstead's production designs for *Vertigo*.

Jessica Huebner supplied her father Mentor Huebner's photo and gave permission to reproduce sketches and Robert Skotak offered his interpretation.

Thank you to Emily Boyle for giving permission to publish her father Robert Boyle's artwork from the Academy and for supplying his portrait picture.

Jennifer Bass gave permission to publish from her father Saul Bass's production sketches for *Psycho*.

Lilian Michelson gave permission to reproduce her late husband Harold Michelson's illustrative work on *The Birds* and *Marnie*.

Storyboard artists Joseph Musso and Thomas J. Wright gave permission to use their sketches from *Torn Curtain* and *Family Plot* and thank you for sharing your memories of working with Alfred Hitchcock.

Craig Barron and Thomas Higginson gave access and permission to reproduce from the Bill Taylor collection of Albert Whitlock matte paintings.

Jodi Routh kindly supplied the photograph of his grandfather Hein Heckroth.

REFERENCES

Dan Aulier, *Vertigo: The Making of a Hitchcock Classic* (2000), St Martin's Press

Mark Glancy, *The 39 Steps: A British Film Guide* (2003), London: I.B. Tauris

Andrew Horton, *Henry Bumstead and the World of Hollywood Art Direction* (2003), University of Texas Press

Elliott H. King, *Still Spellbound by Spellbound Volume 14 Dada and Surrealism* (2018)

Tony Lee Moral, *Hitchcock and the Making of Marnie* (2013), Rowman and Littlefield

Tony Lee Moral, *The Making of Hitchcock's The Birds* (2013), Oldcastle Books

Daniel Raim, *Something's Gonna Live* (2009) [DVD]